BARRON'S ART HANDBOOKS

FLOWERS

BARRON'S ART HANDBOOKS

FLOWERS

BARRON'S

CONTENTS

AN ANCIENT GENRE WITH TRADITION

For a long time, flowers as subject matter were lost in memory, treated as a minor genre, or sometimes overshadowed by other artistic genres; yet, since classical antiquity, they have remained a constant throughout the history of painting. The masterful paintings of garden scenes created by the Greeks and Romans provide the cornerstone for the development of many different styles of painting. At the same time, in the East, a floral tradition developed that was reclaimed by the avant-garde movements at the turn of the century.

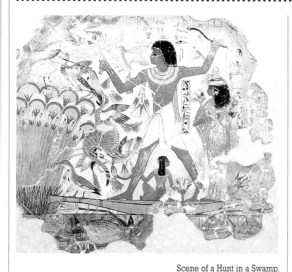

Background

The depiction of flowers and plants in painting has its origins in antiquity. The Egyptian culture highly valued the careful study of nature, and, in fact, many plant species were depicted with a high degree of realism on the walls of temples and tombs. The funerary origins of this style of painting and the meticulous approach used to describe both animal and plant species suggest that these paintings were intended for the gods and for the relationship of the deceased with the world of the dead. Flowers and plants not only represented offerings, but were also proof of the deceased's possessions and status in the world of the living.

Scene of a Hunt in a Swamp.
Mural painting of the New Empire.
British Museum, London.
Plants and flowers have a high degree
of realism in Egyptian antiquity.

Hero on Horseback. Funerary Roman fresco (340 B.C.).
Floral motifs are used in painting throughout the
Greek and Roman periods.

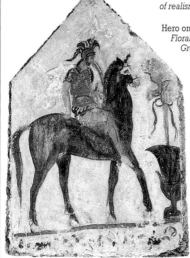

Decoration, Another Window to Reality

In the Egyptian culture, flowers were not only symbolic of the deceased's power on earth, but they also had an important decorative function—to provide a link between pictorial representation and reality. It can be said that the purely decorative element of flowers tied the real and the pictorial worlds together.

In later cultures, floral painting was sometimes used solely for decorative purposes. Examples of this are the flowers and plants found in Greek friezes or in Etruscan paintings of hunting scenes. Roman art was heavily influenced by the cultures that this empire conquered, and used floral representation in mural paintings as an open window to a fictional reality.

*Mural painting from Boscoreale (first century B.C.).
Plants are a significant decorative motif during all periods.*

MORE ON THIS TOPIC

- The study of reality **p. 8**
- Flowers and the avant-garde movements **p. 10**
- Flowers in contemporary art **p. 12**

Mural painting. Livia House, Palatine Hill, Rome.
The floral murals intend to show a nonexistent reality.

A Window to Life

Mural paintings in the form of frescos were the predecessors to paintings done on canvas. Frescos had a wide variety of functions: describing historic or fantastic events, narrating biblical passages by means of various small scenes to people who could not read, or serving a purely decora-tive purpose by simulating windows that shone light into rooms and that portrayed a nonexistent reality. From the beginning of our history, flowers have been a symbol of offering and decoration. For this reason they have often been used artistically to represent a tie between the fictional and the real world.

Mural Paintings

Throughout the various stages of their culture, the Greeks used acanthus leaves and all types of flowers as motifs to decorate friezes, mosaics, and murals. Of these different artistic means, mural painting is practically the only one that has survived antiquity, for time has often erased traces on tablets and tapestries.

Throughout the course of history, murals have mirrored the artistic needs of different cultures. The paintings found inside many of the perfectly preserved Roman houses from the ancient city of Pompeii contain exquisite masterpieces of floral representation.

The Tradition outside the West

Unfortunately, when one speaks of the history of painting, one often refers exclusively to the traditions of the Western world, ignoring other cultures such as the Asian and the pre-Columbian cultures, which were as rich, if not richer, in artistic tradition than the European. Artists of these non-European cultures developed different ways of treating floral painting and used it to decorate all kinds of objects from both everyday and religious life.

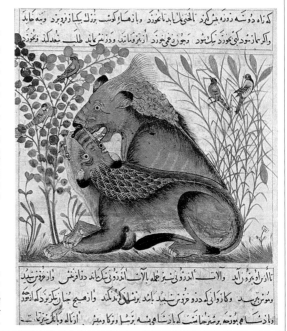

Male and Female Lions.
*Persian Bestiary (1298).
Morgan Library, New York.
Flora and fauna are treated
with great sensitivity
by the Eastern artists.*

THE STUDY OF REALITY

The European Renaissance was the event that transformed the function of flowers in art from an element used to fill in space in still life paintings to an independent theme with its own identity. After the Renaissance, painters decided to study still life objects as a means to explore painting—particularly light and composition—and, in fact, many went on to develop their entire careers based on this theme.

Flowers in Still Life Painting

Still life painting was not called that until the Renaissance period; however, before then, many artists would do paintings as sketches of objects and flowers that they would later include in their compositions.

Flowers are a complex theme that is difficult to develop directly on the canvas. For this reason, artists would often paint several "minor" paintings that would allow them to study the motifs closely before going directly into the painting itself. The result was that many artists, aside from their professional work, had a whole series of secondary work that consisted mainly of sketches and compositions of different plant species. Although flowers have always been an important subject in still life painting, it is important to know that the term *still life* applies to all works that feature objects as the primary subject matter.

Caravaggio (1573–1610), Fruit Basket *(detail). Ambrosiana Gallery, Milan. This painting is considered the first in the history of the still life genre of painting.*

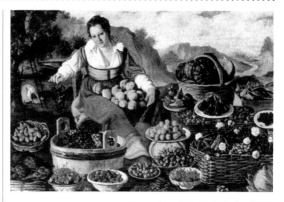

Vicenzo Campi, The Fruit Vendor *(1560). Brera Gallery, Milan. Paintings of flowers and fruits were not considered part of the still life genre until after Caravaggio.*

The Genre's Forerunner

Before Caravaggio (1573–1610), artists did not attempt to create still life paintings that were worthy of artistic merit as such. Following him, however, artists began to specialize in the painting of flowers and soon began to achieve unprecedented levels of perfection.

Once still life painting was established as a genre, the eighteenth-century Dutch school developed very significant work that consisted mainly of small paintings of flowers done on tablets. The commercialization of these was easy because of their quality, price, and size. One of the most significant painters of this time was van Huysum who produced flower paintings of outstanding quality. Since the eighteenth century, many artists have painted flowers regardless of their specialty. Some artists have chosen to make them the main subject of their still life compositions, and others have used them to complement portraits, landscapes, and other subject matter.

The Evolution of Artistic Representation

It is very important for artists to carefully study the processes of change that occur in many artistic currents in order to be able to approach painting critically. Once artists are aware of the different ways in which flowers have been painted over time, they will be able to create work that is more complete and coherent.

The Development of Pictorial Styles

After the eighteenth century, flower painting developed in a revolutionary fashion. A great number of French painters spent their time and artistic genius searching for ways to further elaborate on the theme. Jean Baptiste-Simeon Chardin (1699–1779) was one of the most significant of these painters. His sober and simple compositions focused on various kinds of plants, and contained a quality of light and color that had a great influence on later works.

Another important figure in this genre is Henri Fantin-Latour (1836–1904). His paintings are almost photographic in their realism, and his style is based on a subtle approach to chromatic tones and a careful study of light.

Jean Baptiste-Simeon Chardin (1699–1779), Flowers in a Blue Vase. *National Gallery of Scotland, Edinburgh.*

Herbalists and Scholars

The artist has often been a dedicated observer of nature. From the time of Leonardo da Vinci to today, painters have taken careful notes on wildlife in order to study it more closely. During their overseas expeditions, botanists had the important task of documenting a wide variety of flowers. The amount of information and detail collected in the form of these drawings and paintings made their notebooks virtual herbariums.

MORE ON THIS TOPIC

- An ancient genre with tradition **p. 6**
- Flowers and the avant-garde movements **p. 10**
- Flowers in contemporary art **p. 12**

Henri Fantin-Latour (1836–1904), Still Life with Dahlias and Hydrangeas. *Toledo Museum of Art, Toledo, Ohio. Compare the artist's perspective and modeling technique in this painting to that of Chardin.*

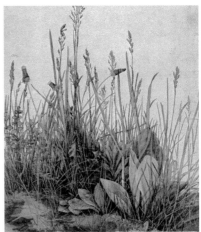

Albrecht Dürer (1471–1528). The Great Farmland *(weeds). Albertina Museum, Vienna. Artists have always appreciated the documentary value of flower representation.*

FLOWERS AND THE AVANT-GARDE MOVEMENTS

The avant-garde movements that began in Paris, starting with the Impressionist movement (1874), reclaimed all previous genres of painting and gave them a new perspective. Objects were no longer seen purely as subject matter, but were used instead as a means for the artist to study painting as a process and to develop the study of light. Flower painting claimed a leading role in the study of painting, for the combination of light and color present in the same subject matter allowed artists to make great technical and artistic advances.

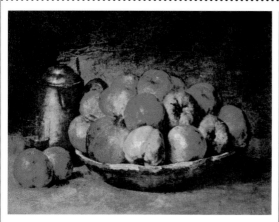

Gustave Courbet (1819–1877), Apples and Pomegranates. London, National Gallery. Simplicity, reality, and austerity formed the basis of realism.

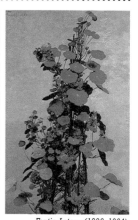

Fantin-Latour (1836–1904), Nasturtiums. Victoria and Albert Museum, London. Fantin-Latour tied Realist and Impressionist trends together.

From Realism to Impressionism

Ever since Gustav Courbet (1819–1877) started the Realist trend, painting was understood in an entirely new way. Flower painting had always been done using a model, whereas landscape painters who worked academically in the period before Courbet tended to rely on memory. Realism did not only stress the importance of using nature as a model, it also implied that the artist would take a realistic and not utopian approach to the subject, in other words, if the flowers the artist was using as a model were wilting, then he or she would accurately represent this; if they were placed in a crude vase, the artist would respect this and not add elaborate touches.

Advances in the Concept of Painting

Before the Realist revolution, the representation of flowers had often been done on rich velvet or silk embroideries. The subject did not acquire a truly serious and simple nature until "painterly" painting was imposed on the bourgeois classicism of the Academy. The Impressionists left aside everything from the dramatic aspect of classical scenes to the overvalued approach taken to the subject. In any event, academic painters had never considered flowers to be a subject of great transcendence. The Impressionists, on the other hand, did not intend to find transcending qualities in their subject matter at all, but rather in the painting

itself and for this reason simple and humble themes—flowers included—became of great importance.

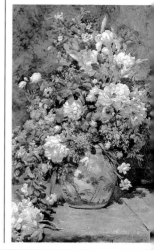

Auguste Renoir (1841–1919), Spring Bouquet. Fogg Art Museum, Cambridge, Massachusetts. The Impressionists suggest that the mixture of color occurs in the viewer's retina.

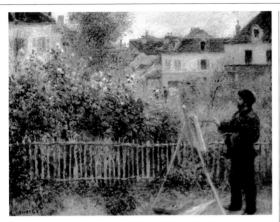

Auguste Renoir, Monet Painting in His Garden. *The Wadsworth Athaeneum. Painting outdoors allowed artists to capture flowers in nature.*

The Great Colorists

The Impressionists had a very different way of depicting their subject matter than the classical painters. Their main concern was the way light reflected on different objects, in this case, flowers. The Impressionists did not express the different colors of a flower as tonal variations but rather as individual colors, taking a fresh look at each one and distinguishing between colors that were exposed to light and those that lay in shadow.

The Impressionist color theories were reclaimed by Gauguin (1841–1903) and van Gogh (1853–1890), who gave color a symbolic meaning by not representing reality as it is but instead expressing color the way the artist personally perceived it.

Color for Color's Sake

The Postimpressionists did not intend to paint flowers that reflected the actual model, but used their own color, which depended more on the palette used in the overall composition than on the original subject. The juxtaposition of colors was also common in Postimpressionist painting. Pure and sometimes complementary colors, instead of

tonal variations, were placed next to each other to create vivid contrasts. As a result, flower painting reached new levels in terms of the artist's creative effort, and was given a new freedom in terms of resources and forms.

Close to Abstraction

It is not difficult to observe the evolution of the approaches to painting following the Impressionist movement. This century has been one of constant search and develop-ment from realism to abstrac-tion, and nothing comes closer to the process of abstraction than the observation of trees and their structure, which is precisely what artists such as Mondrian (1872–1944) did in order to reach their abstract conclusions in painting.

MORE ON THIS TOPIC

- An ancient genre with tradition **p. 6**
- The study of reality **p. 8**
- Flowers in contemporary art **p. 12**

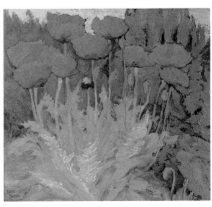

Emil Nolde (1867–1956), Large Poppies. *Private Collection, London. Gauguin's fauvism was developed with the nabies (Moorish prophets). Complementary colors are juxtaposed.*

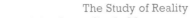

Vincent van Gogh (1853–1890), Sunflowers. *Rijksmuseum, Amsterdam. The colorist approach to painting together with van Gogh's genius gave way to Expressionism.*

FLOWERS IN CONTEMPORARY ART

Cézanne (1839–1906) introduced a whole new way of understanding both painting and reality. He carefully studied every single plane of his subject matter, and developed a style that would later be very significant to geniuses such as Pablo Picasso (1881–1973). Picasso in turn, would develop the foundations on which contemporary painting is built. Still life painting and flowers were important themes that propelled the techniques and approaches to painting we have today.

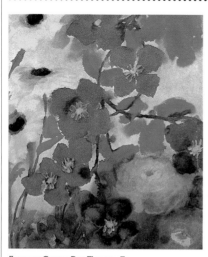

Francesc Crespo, Dry Flowers. *Tempera on paper. Private collection. Painting today incorporates the ideas of the avant-garde movements from the turn of the century: synthesis and colorism.*

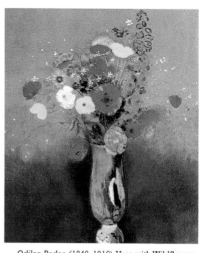

Odilon Redon (1840–1916), Vase with Wildflowers. *Pastel on paper. Musée d'Orsay, Paris. Painting flowers allows the artist to develop different techniques and attitudes toward art using everyday objects.*

The Process of Synthesis and the Reason to Create

Painting flowers allows artists to concentrate all the strength of their painting skills into one of the most delicate elements of nature. In many cases, the flower is a subject matter that artists use to test their ability to understand the model and synthesize their observations through drawing and color. In some cases, however, painting flowers is simply an excuse to paint and therefore create. One of the best resources for artistic creation is the use of everyday objects as models, and there is no better subject matter than flowers, which embody the mystery of color and an enormous complexity of form.

Approaches to Artistic Development

Following the development of various avant-garde movements, the freedom to create took hold of all different kinds of painting allowing the public to recognize

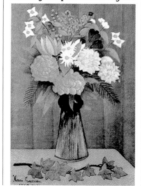

Henri Julien-Rousseau, Vase with Flowers. *Albright-Knox Art Gallery, Buffalo, New York. Rousseau developed some of the most interesting naïve (innocent) art of the twentieth century.*

the academic artist and the "free" artist as separate. Today, any creative current is valid, from the most traditional approaches studied in all schools and academies of art, to the newest ideas and trends. The use of flowers throughout history has remained a constant, while process and technique has changed.

The painting of flowers can be approached in many different ways—from a Realist perspective, where forms and colors are expressed through tonal variations; a colorist perspective, where one tends to depict each tone as a pure color without using grada-

tions; a naïve perspective, in which painting is understood in a simple fashion without searching for a formal truth; an expressionist perspective, where one gives strength to the expressive aspect and liberty to the stroke; and, finally, a totally abstract perspective, where colors are understood as fields, and forms as planes that are different from those in real life.

Subjects

While painting flowers allows for the absolute development of the artist's creativity, the complexity of the subject poses one of the greatest challenges. This does not mean that the subject should be approached by only a few; on the contrary, it means that beginners as well as professional artists will always find flowers an interesting challenge.

Flowers as subject matter can always be found in nature and in the studio, allowing artists to manipulate their subject to accommodate their preferences. If one single subject is used on various occasions, artists will be able to extract and compare a variety of results in their work.

The Search for a Motif

It is important for painters to study work from artists of all peri-

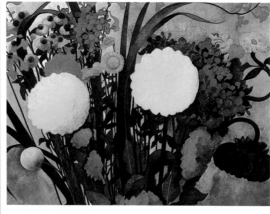

Edward Burra (1905–1976), Flowers. *Private collection. This painting is based on a bouquet placed in a vase.*

Oskar Kokoschka (1886–1980), Flowers. *Private collection. This great painter based this piece on some wildflowers.*

MORE ON THIS TOPIC

- An ancient genre with tradition **p. 6**
- The study of reality **p. 8**
- Flowers and the avant-garde movements **p. 10**

ods, in order to be able to find interesting motifs that they can refer to and use in their own work. Learning to paint flowers is a task that requires time and dedication, but it is also a theme that can be very satisfactory for an amateur painter.

Conception and Abstraction

To conceive of a flower painting is not a simple task; it depends on the composition defined by the artist as well as the process he or she chooses to follow. Both of these factors vary widely from artist to artist and are heavily influenced by the ongoing trends. If one reviews the work of the many artists that have influenced the formation of artistic trends, one can see a wide range of conclusions that originated with the same theme. An interesting exercise is to find the place where such artists left their work, and rework the theme in order to reach new conclusions about painting.

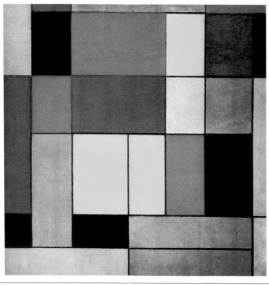

Piet Mondrian (1872–1849), Composition in Red, Yellow, and Blue. *Tate Gallery, London. Mondrian's abstract results in painting originated in his study of trees.*

THE ARTIST'S MEDIUM

Flowers are a favorite theme for many artists, both abstract and figurative, as well as for those who are just learning, because some of the best results can be derived from working with this subject. All different mediums are ideal for working with flowers, but given that each one allows the artist a wide range of possibilities, it is important to become acquainted and to experiment with them in order to obtain the desired results.

Drawing, the Study of Composition

Drawing is the basis of all artistic representation. The development of line and value through the use of gray tones is the beginning of any kind of artistic representation. Flowers require detailed study that will allow the artist to lay down the basics on the canvas using preliminary drawings. Eventually, the artist's observations will take a complex form through the use of paint.

At the same time, drawing is a wonderful artistic medium, regardless of whether it is connected to painting or not. Drawing can take the shape of a line, a surface, or plane, or of a gray tone scale. The basic mediums used for drawing are pencils, conté, charcoal, and a blending stump.

MORE ON THIS TOPIC

- Other mediums **p. 16**
- Learning to see **p. 18**
- Resources for synthesis **p. 20**
- Geometric approximation **p. 22**

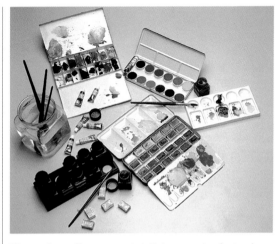

Watercolor, a Transparent Medium

Of all the different artistic mediums, watercolor is perhaps the most delicate and complex. It is completely transparent, and for this reason whites are defined by the paper itself. Once the colors have dried they are permanent; in other words, it is impossible to make corrections on a watercolor painting. As a result, this medium poses a great challenge to the artist. Water-

Various examples of watercolors.

colors have a particularly luminous quality because of the mixture with water that they require. To use this medium one simply wets the paintbrush and mixes it directly with the watercolor, and, depending on the amount of water used, different levels of transparency can be achieved.

The number of shades that one can create using the watercolor technique are innumerable. One single color can be worked into an extensive tonal scale of transparency, and each one of these tones can be shaded with thousands of colors in different densities. This means that flowers can be painted with a great intensity of color and light.

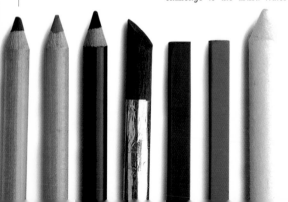

Material used for drawing: conté and charcoal pencils, charcoal stick, conté crayons, and blending stumps.

Oils—Process and Tradition

The oil technique is complex and implies a labor-intensive process, not only because of the detailed preparation of materials required, but also because the painting process itself is very involved; however, oils permit the artist a great amount of flexibility. This is probably the most versatile of all artistic mediums because of its slow drying and the fact that it allows for continuous reworking of the painting. It therefore can easily be used by both amateur and professional artists alike. The main advantage of using oil is the malleability of the medium itself and its possibilities for correction at any stage of the painting's development.

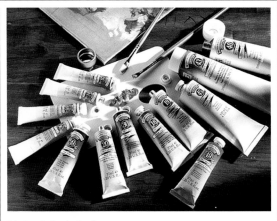

Display of oil paint in tubes.

Pastels—Freshness at the Moment

If there is one medium that should be characterized for freshness and luminosity, it is the pastel medium. Pastels are made of chalky lime, tragacanth gum, and pigment. They come in an extensive range of colors because the colors themselves cannot be mixed together without losing their characteristic freshness. Painting with pastels means paint-

ing with pure pigment. The medium is versatile; it can be layered for more density of color or blended at any time, since it requires no drying. This can sometimes be a disadvantage, however, for the painting can be spoiled at any point with the slightest accidental brush that could produce an undesired smudge.

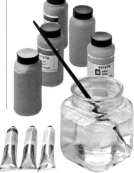

Acrylic paint can be diluted with water while it is fresh. It comes in tubes and jars.

Pastels come in an extensive range of tones so that mixing can be avoided.

Acrylics—Modernity and Technical Advances

Acrylic paint is the most modern medium. Its composition—a resin polymer in an aqueous suspension—is characterized by rapid evaporation. Acrylics dry into all kinds of finishes ranging from a watercolor-like finish to a thick, dense finish that is not unlike oil paint in appearance.

Choosing a Medium

The medium in many ways defines the process that will be used to paint the picture. Each medium allows artists different possibilities; they should develop their own criteria for choosing to work with one over another. No medium is better than another; the results will depend on the artist and they should be the main criteria for the choice.

Each situation may require a different medium; for example, pastels, watercolors, and acrylics are good for quick painting, oils for detailed studies.

OTHER MEDIUMS

The possibilities for artistic representation should not be limited to the medium the artist is most comfortable with; it is always interesting to experiment with new or unfamiliar techniques and procedures. Even for those artists who have a lot of experience with one particular technique, trying out new ones can always prove surprising and lead to new creative options. Experimentation should always be a constant for any artists who take themselves seriously; testing and studying the processes and techniques used by other artists should also be of equal importance.

Markers and Pens

Markers and pens can be used as drawing mediums with results that are not too different from those achieved using watercolors. The colors they produce are totally transparent and can be fused together or superimposed as sheer layers.

Using these mediums is not altogether different from using watercolors because there is no white. One must build up the transparent layers of color and allow the paper itself to account for the whites. The way in which the color will be applied depends primarily on the shape of the marker or the pen's tip. All different kinds exist: brushlike and felt, or flat, round, and square tips; micro-tip pens are recommended for delicate work, such as the details on a leaf.

Different tips on markers and pens.

MORE ON THIS TOPIC

- The artist's medium **p. 14**
- Learning to see **p. 18**
- Resources for synthesis **p. 20**
- Geometric approximation **p. 22**

Colored Pencils

Despite what everyone thinks, colored pencils are not made to be used only in school; many professional artists use this medium for their floral creations. When using colored pencils, pens, and markers, one assumes paper will represent the white and light areas. White pencils do exist, but are used primarily to suggest light, and the color is added to the work as a final touch.

The possibilities for using colored pencils to draw flower themes are tremendous. One should also remember that high-quality watercolor pencils exist and that they allow the artist to combine the use of a pencil with the watercolor technique.

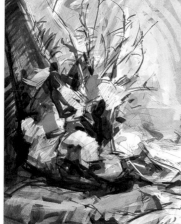

The ink from markers and pens is soluble in alcohol and water, and allows for effects similar to watercolors.

It is important to have a wide range of colored pencils.

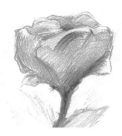

Using colored pencils as a medium allows the artist to superimpose colors and lines.

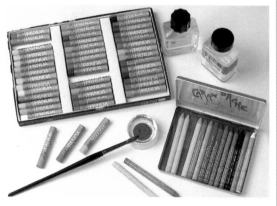

Wax and Water-Soluble Mediums

Encaustic paint is a mixture of wax and pigment, which implies that it is sensitive to heat and tends to fuse. Encaustics can be dissolved using paint thinner and can be mixed with oils. These possibilities make this seldom-used technique one of the most interesting to work with in floral representation.

Wax is totally incompatible with water-soluble mediums, which means it can be used as an impermeable substance to block off the sections of the surface where the artist later intends to use such a medium. This kind of process is known as mixed-media.

Other mediums exist that are either infrequently used or rather unknown, but may be useful to work with in floral representation. Water-soluble oils are an example similar to acrylic paint, for they allow the artist to clean the brush with water instead of turpentine.

Oil Pastels

Oil pastels have similar characteristics to regular pastels, and allow the artist to achieve surprising results. Mixing different color oil pastels is possible but not recommended because they tend to lose their luminosity. This medium, however, is very useful for creating lines, areas of color, and other types of sketches that will serve as a base for the actual oil painting.

Wax and oil pastels are soluble in turpentine and are compatible mediums.

Investigating the Genre

Among the different kinds of themes that allow the artist to investigate painting, still life compositions have the greatest number of possibilities. Objects and flowers serving as models are always structured in a much simpler fashion than a landscape or a portrait. Once the structure of the forms used in the composition has been determined, the artist can freely approach other issues of painting, such as creativity and imagination.

Water-soluble oils tend to dry quickly.

Mixing different techniques may bring interesting results, as long as you take drying times and thick-on-thin paint applications into consideration.

LEARNING TO SEE

The difficulties that arise when representing flowers are not always a reflection of the artist's capabilities, and can usually be solved with a clear understanding of the subject. In fact, every object in nature can be reduced to simple geometric elements in order to clarify the artist's understanding of the object and facilitate the actual painting process. Knowing how to see is a major part of the artistic process when it comes to representing flowers and all the other objects that often times surround them.

A

A—The shape that provides the main focus of the composition should be abstracted.

B—The general shape of the subject can be defined once the surrounding space is understood.

B

Observing the Subject

One of the greatest problems that the amateur painter faces is not knowing where to begin. The subejct often presents itself as a great mass of complex forms, a factor that should not intimidate the artist. One should understand the subject as a uniform group of shapes and not separate its various elements; for example, a bouquet of flowers placed in a vase should be seen from the very beginning as one single shape or mass. Approaching the subject this way will help the artist understand the spatial relationships between the different objects in the composition. A good way to try to understand the subject as a single mass is by imagining the space that surrounds it and omitting the various elements that make up the subject, in this case, the individual flowers and the vase.

Any subject matter can appear difficult if it is understood as a jumble of small objects.

The Focal Point

Once the artist has established the overall shape of the model, the balance should be determined. This will help establish the composition of the work and should also provide reference points that will be useful to understanding the relative proportions of the objects. The process is simple: After imagining the space that surrounds the subject, one should identify its symmetry, in other words, the imaginary line that divides the subject in two identical halves. Next, the relationship between the upper and the lower parts of the subject should be determined in order to understand the proportions. The initial sketch must take all of these factors into consideration. Once the primary shapes have been determined and the reference lines have been laid down, these can be subdivided symmetrically in order to create new spaces that hold the different shapes of the subject.

MORE ON THIS TOPIC

- The artist's medium p. 14
- Other mediums p. 16
- Resources for synthesis p. 20
- Geometric approximation p. 22

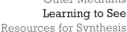

Looking and Observing

Looking and observing are not the same thing. Every day we look at objects without analyzing them consciously, and usually we take in no more than their external appearance. Observation, on the other hand, allows the artist to penetrate the object and scrutinize its structure, weight, and the density of its shapes. Observation is the only way to understand an object and be able to represent it in a clear and concise manner.

Synthesis by Gazing

Knowing how to see means knowing how to synthesize; for this reason, the subject must be seen through the eyes of the painter, not the photographer. The subject becomes a loose combination of shapes and colors, something similar to an object seen through half-closed eyes. Certain areas become less defined and yet the general shape is understood more clearly. Paintings that present excessive detail can appear to be competing with reality; however, painting must be understood as a two-dimensional world that runs parallel to our reality, not one that competes. The undefined shape that painters see as their subject should ultimately help them understand or explain the object that they are working with.

Choosing the Subject

It is important for the artist to choose a good subject, as the final product's success depends partially on this choice. One must take into consideration that flowers have a relatively short life span, and therefore the kind of flowers that the artist chooses should be able to live at least the same amount of time intended for the painting or other kind of artistic creation. Some flowers, such as carnations, roses, and daisies, last longer than others once they've been cut, therefore allowing the artist to work for a few days.

Light is what brings out the intensity of color in the flower's petals, and for this reason, the subject should not be moved from its original place once the session is begun.

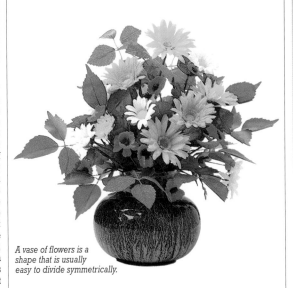

A vase of flowers is a shape that is usually easy to divide symmetrically.

Once the subject has been divided symmetrically, the two halves can be developed in a parallel fashion. The reference lines can be divided further to create areas that will make it easier to understand the detailed and complex parts of the model.

RESOURCES FOR SYNTHESIS

According to its definition, synthetic is not analytical, but instead is something compounded, a whole resulting from the combination of parts. Synthetic can also mean an artificial product that mimics the composition and properties of a natural substance. Both definitions apply to the results of artistic interpretation; in other words, the reality embodied in the model is reduced to a two-dimensional interpretation on canvas. Capturing reality—in this case flowers—implies a great effort from the artist to synthesize; it means understanding the subject and carrying it over to the surface of the canvas. The artist will have to detach from extraneous or unnecessary detail embodied in the real subject and bring to the painting only those elements that are truly necessary.

Direct Drawing

The general volume of the shapes is what the artist should first direct his or her attention to, for the painting should be constructed using volumes of masses that are proportional to one another. The subject can be understood generally, anticipating that the lines and shapes used to create the initial sketch are not so much a simple drawing, but rather a means of transmitting the idea or feeling behind the drawing; the initial sketch should be something immediate, loose, and direct. Practically any medium, including an ordinary pencil, can be used to create this kind of sketch. An energetic stroke will provide the painting with an extra boost.

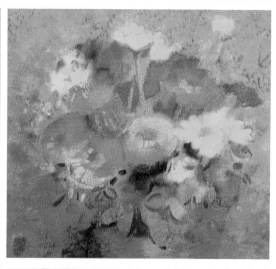

The Study of Composition

Composition is an art that consists of finding the perfect balance between the different objects that are distributed throughout the painting. The subject of flowers is intimately linked to the way the flowers themselves are presented and distributed in the painting; for this reason, the artist's skill at synthesizing the various elements is of great importance. The objects used in the painting should be understood as purely geometric elements; with this as a starting point, the artist can proceed to synthesize the shapes that make up the subject according to the plane they occupy in the painting. Whether the subject is composed of one or more objects is not important; the real concern is the way they are distributed throughout the painting.

In this example, the subject is understood in a direct way.

In another example, the combined elements are understood as gestures of color and volume.

The immediate drawing can capture the subject matter by synthesizing various elements. Notice here how the flower has been drawn.

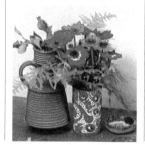

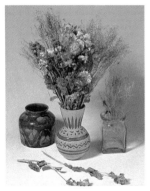

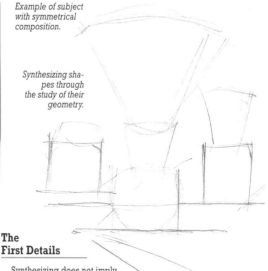

Example of subject with symmetrical composition.

Synthesizing shapes through the study of their geometry.

General Approximation

The process of synthesizing in a painting is not limited to the initial study embodied in a geometric sketch; instead, it takes place at every step of the way. The painting process can begin with a sketch that synthesizes certain aspects of the model by attempting to recreate its primary elements through washes while ignoring the specific definition of each shape. This general approximation, from subject to painting, provides the first hint of what the painting will represent. If the artist is working with flowers, the initial phase of artistic representation will be manifested in a sketch that intends to serve as a visual aid and does not necessarily represent reality. The sketch is based on washes of color and does not attempt to present any sort of detail.

Synthesizing shapes through the use of color.

The First Details

Synthesizing does not imply creating a particular kind of work when it comes to painting flowers. All artists should find their own method of reducing the various elements of the object and the best way to apply this to their work. The initial drawing could synthesize the model by creating a detailed chromatic work, an interesting and practical departure point for the artist. The process of synthesizing can sometimes be similar to pointillism, for the model is understood as pure areas of color that complement one another and have the overall effect of defining shape. This kind of work allows the artist to synthesize not only the shape but also the color of the different elements in the composition.

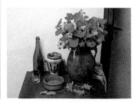

Studies in Composition

The process of synthesizing is necessary for all artistic representation. It should be considered not only while the drawing or the painting is in progress, but also during the time when the composition of the work is being defined and the placement of the subject is being considered. A complex painting is not always a good painting. When using flowers as a subject, it is a good idea to "simplify" the shapes by shifting around the placement of the flowers until they fit the desired composition.

MORE ON THIS TOPIC

- The artist's medium **p. 14**
- Other mediums **p. 16**
- Learning to see **p. 18**
- Geometric approximation **p. 22**

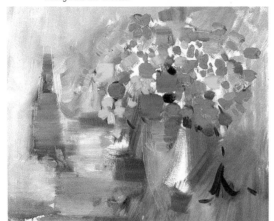

GEOMETRIC APPROXIMATION

All objects in nature can be reduced to their minimal expression through art by eliminating anything extraneous in order to understand the basic, internal shape of the object. Flowers and the objects that surround them in still life painting are not exempt from this process of synthesizing and reduction; in fact, learning to reduce the different elements of the model to their basic geometry will simplify the future development of these shapes on the canvas.

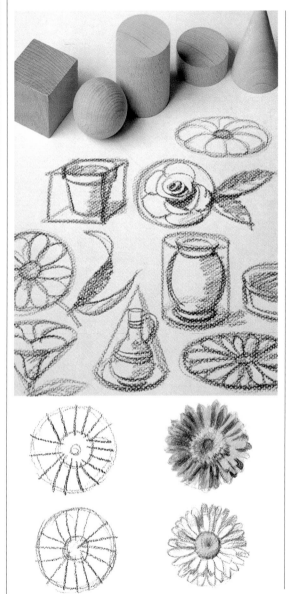

Basic shapes and how they translate onto a plane.

The Basic Elements

Any subject that we take the time to observe will reveal shapes that, although complex, will tend to be part of a larger and much simpler shape. It is essential for the artist to understand these basic shapes before beginning to do any sort of work on the canvas or paper. The basic geometric shapes or forms are cubes, spheres, cylinders, and cones. On paper, these shapes translate into squares, circles, and pyramids. These geometric shapes are the basis for any subject, in this case flowers.

Knowing How to Draw Is Knowing How to Understand

A flower can appear to be a very difficult subject to represent if its basic structure is not understood previously through drawing. No object can be drawn if its internal structure has not been totally understood; in other words, one must understand the object's simplest elements and the basic planes on which it lies before attempting to represent it. A flower can easily be reduced to a simple geometric shape. This shape will then provide the

A few simple lines suggest the structure of a sunflower.

Another example of the schematic use of the circle.

starting point from which the flower can be developed using other lines that explain its composition and volume.

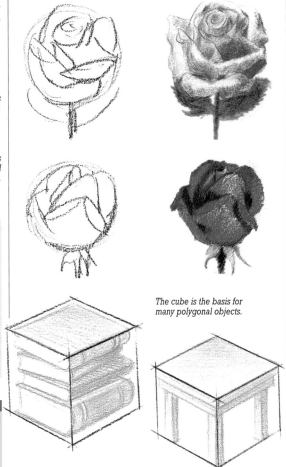

This sketch of a rose is based on a circle.

The volume of the rose fits perfectly into the simplified shape of a sphere.

The Descriptive Process

Describing a floral composition through drawing is a progressive process that works toward defining the model's different shapes. One should always start with generalities and work toward specifics. The complexity of a still life painting is gradually defined by the different stages of development of the painting.

The cube is the basis for many polygonal objects.

MORE ON THIS TOPIC
• The artist's medium **p. 14**
• Other mediums **p. 16**
• Learning to see **p. 18**
• Resources for synthesis **p. 20**

Synthesis of Shape

A bottle and a teacup are easier to approach when they are seen as basic cylindrical shapes.

Elements in the composition that surround the flowers can sometimes appear to be more complex than the flowers themselves; however, the only complexity with regard to these other elements is knowing how to ascribe to each one a particular geometric shape that applies to the perspective of the plane they occupy. For example, a pile of books or a table can fit perfectly into a cubic shape. Other objects that usually surround flowers and are specific to still life compositions are bottles and various containers; these can fit perfectly into a cylindrical shape. And finally, fruits and other shapes, such as a light bulb, have a structure that is not unlike that of a sphere.

LIGHTING AND THE SUBJECT

One of the most important factors in the study and preparation of the subject is the lighting. The colors of the petals depend entirely on the light that touches them, whether direct or indirect, and regardless of the presence of reflecting points. A detailed study of the lighting will be very useful for the future development of the painting, considering that all the objects in the composition are interrelated by the light they reflect and the source that illuminates them.

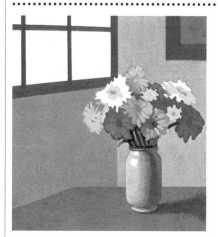

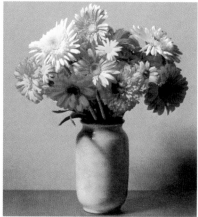

An example of indirect light on the subject. The shadows it creates are very soft.

Indirect Natural Lighting

Daylight is what we consider natural light. If the object that is being used as a subject is inside a room, the light will fall on it in a more or less indirect fashion depending on the distance between the subject and the main source of light, in this case the window.

If the subject has been placed a certain distance away from the window, the light that touches it will be dispersed throughout the room creating softer shadows and lighter contrasts than if the subject were placed next to the window.

Overhead Artificial Lighting

Electric lighting livens colors, but produces a double effect on the objects it illuminates, making them seem flat and casting pronounced shadows. A good way to

Chiaroscuro effect using an electric lamp.

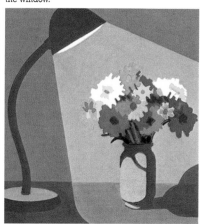

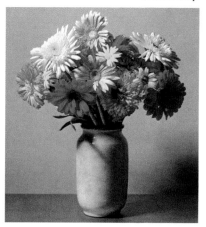

counteract these possible defects in lighting is to place a piece of white Bristol board near the subject to compensate for the flatness by dispersing the light. A lamp placed directly above the subject creates a *chiaroscuro* effect (strong contrasts of light and shadow), which is very interesting from an artistic point of view.

Direct Natural Lighting

When the subject is placed close to the window the light falls directly on the side that faces the light source. The shadows that are created, however, are not as dark as the ones produced by artificial lighting due to the fact that when the light enters the space that the subject is in, it reflects off the walls and other objects in the room, and falls on all surfaces of the subject. This kind of lighting intensifies the colors that are in half-shadow and prevents the ones that are totally illuminated from appearing in their natural tone because of the light's strength.

When placed in front of a window, the shape and volume of the motif is defined by the light that enters the room.

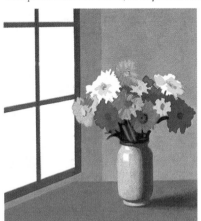

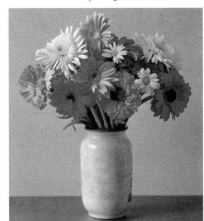

The Effect of Backlighting

As the term describes, backlighting means placing the object between the main light source and the viewer. Backlighting may be direct or indirect—direct if the subject is placed right in front of the light source, leaving the side that faces the viewer in complete darkness, and indirect if the subject is placed a short distance from the light source so that the effect of the backlighting is counteracted with a soft glow on the darker side of the subject. Backlighting creates an interesting contrast between the plane on which the subject lies and its background, and also makes the subject appear very important compared to the other elements in the composition.

MORE ON THIS TOPIC

• Preparing the subject **p. 26**

Indirect backlighting using natural light. The light source is to the right of the composition and is compensated by the dark background.

Direct backlighting using artificial light. The light source is located almost directly behind the objects.

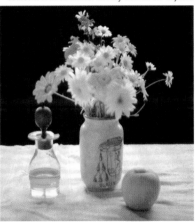

PREPARING THE SUBJECT

Before beginning the process of painting, the artist needs to prepare the subject (flowers in this case). The flowers need to be selected, and the other objects that will be used to create the most appropriate and desired composition should be available. Once the materials have been placed on the surface where they will rest while being painted, the most exciting and complex part of the process begins: mounting the still life and shaping the flowers.

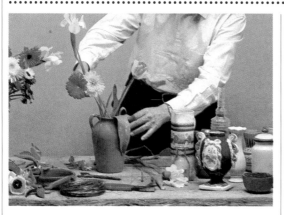

Preparing the subject takes time and organization.

Supplies for Preparing the Subject

The work that is done before mounting the still life tends to be complicated and takes a certain amount of time, but is absolutely necessary in order to mount an attractive still life that harmoniously combines forms and colors. The flowers should be as fresh as possible so that the session can last for as long as the artist needs it to without the flowers deteriorating. Dry or plastic flowers are also an option. The supplies used to arrange the flowers are varied: scissors, a water spray bottle, wire, synthetic cork to hold the bouquet, etc.

The containers chosen to hold the flowers are also a very important element, and the results achieved in the final painting will reflect these initial choices made by the artist.

Mounting and Lighting

Once all the material that will be used as part of the still life composition is ready, the structure should be studied carefully before finalizing it with the placement of the flowers. If the painting surface has a vertical format, then the structure of the still life should imitate it and also be vertical. The way the different elements of the still life are arranged will influence the choices the artist makes when composing it on canvas. Similarly, if the available objects are of a generally horizontal form, the painting's format should take this significant factor into

consideration. The process of mounting the subject will not be completed until the right lighting has been determined.

This subject is appropriate for working on a vertical format.

Selecting the Flower

Artists should consciously choose the kind of flower they want to use in their composition. If the work is of a very specific nature, the flowers should have all the characteristics that the painter desires for his or her painting. If the subject that is chosen is not a good one, no matter

Horizontally placed subject.

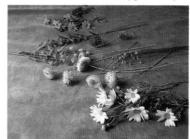

how good the artist's technique is, the final product will always reflect an initial poor choice. Each of the flowers should be chosen carefully. If the desired subject consists of a bunch of wilted flowers (sometimes a source of great beauty), the artist should be aware of the way different flowers wilt and choose the subject accordingly. It is important to remember that a flower goes through many stages in its life, starting as a bud and dying by dropping its petals or wilting.

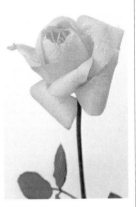
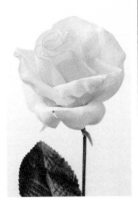

The subject should be deliberately chosen. These two roses are different from each other.

When painting a group of wildflowers, the main concern should be how the subject works as a whole and not the individual flowers.

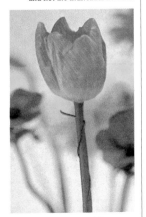

By winding wire around the stem, the artist is able to manipulate the flower's shape.

Resources for the Subject

Before delving into the painting process, the subject must be manipulated by the artist to portray the desired image. If the flower or group of flowers is too limp, a thin wire can be wound around the stem to sustain its weight in an upright position. This technique also allows the artist to bend the stem in any desired direction.

One of the most practical resources available is taking a photograph of the subject. Attention should be paid to the light and film that is used; if artificial light (tungsten) is used, the film should be appropriate for that kind of lighting.

MORE ON THIS TOPIC

· Lighting and the subject **p. 24**

A Natural Appearance Requires Preparation

A masterful composition rarely happens casually or by coincidence. If the artist is interested in creating a simple and natural composition, the preparation of the subject matter will be very important. A good example is this painting by Charles Reid (1942) because it shows how the placement of every element of the still life composition, including the position of the lilac-colored flowers, has been carefully considered as part of the painting process.

Charles Reid (1942). Baccaro Iris. Watercolor on paper. Private collection, courtesy of Watson-Guptill.

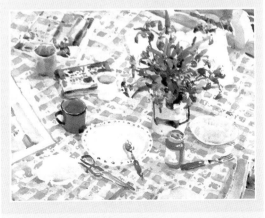

USING OIL PAINT

Oil paint has long been used to represent flowers because of the wide range of possibilities it allows the artist. Using oil paint is advisable for creating work that is intended to be complete on all levels. The chromatic quality of oil paint remains stable and brilliant at all times, and the richness of the paint, most apparent during its application, facilitates color transition, blending, and tonal gradation. This medium, however, requires different materials to facilitate its use, such as a liquid medium to dissolve the paint and to clean up with, and something to arrange the colors on and to transport them with.

A Medium Rich in Resources

The pasty consistency of oil paint results from the agglutinated mixture of pigment and oil, a combination that gives the medium very specific characteristics, such as slow drying. Oil paint is easy to manipulate in many different ways during the painting process, either fusing colors or applying dense, thick layers of paint with the paintbrush or with a palette knife. In order to use this medium correctly, it is necessary for the artist to have a set of fine and thick paintbrushes, as well as palette knives, a palette, squirt bottles, turpentine, linseed oil, and rags for cleaning. The paint tubes are best kept in a case that is intended for their storage. These cases can be found in art supply stores and come in varying sizes and quality.

Complete set of supplies needed for oil painting.

Various oil paint colors. Their chromatic richness and texture are second to none.

Chromatic Richness

A few of the characteristics that make oil painting an ideal medium for painting flowers is the chromatic richness, the variation of tones, and the perfect stability of color they offer once they have dried. For painting that requires a great amount of detail, oil paint is almost indispensable. The chromatic richness of oil paint allows for subtle changes within the different color ranges. The colors can be easily mixed and one can be sure that once they have dried, they will remain unaltered. This is not feasible with other painting mediums such as watercolors or acrylics unless they are of a very high quality; however, it is also true that oil paint of higher quality offers the best color ranges, accompanied by higher prices.

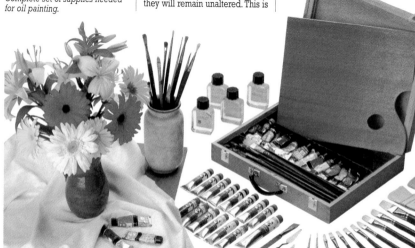

Presentations

Depending on the way the oil paint is going to be used, different types and sizes of tubes and cases can be purchased. Painting in the studio allows the artist to keep close at hand a large case full of many kinds of oil paint in different sizes and colors; however, if the painter decides to work outdoors, it can be an annoyance to try and transport all the studio supplies to the work site. For these occasions, small cases should be considered for carrying a limited range of colors (but not so limited that it will keep the artist from achieving chromatic richness). Small oil paint kits are available in different qualities and prices depending on the quality of the oil paint itself, the fabrication of the case, and how complete the kit is. Ideally, it should include linseed oil and turpentine, a palette, a place to keep the brushes, and a range of at least 12 colors.

The Color Chart

The color chart is a perfect guide for the painter and a good way to see the various color ranges created by different brand names. A color chart is also useful (and should ideally be printed in a high quality) for the artist to know what colors are available on the market. Generally, art supply stores have these charts available to the client but they can also be found in art theory publications.

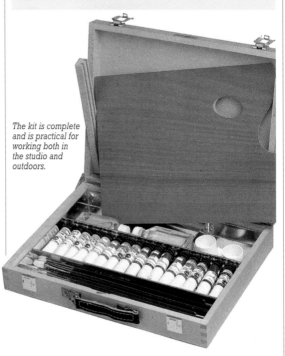

The kit is complete and is practical for working both in the studio and outdoors.

MORE ON THIS TOPIC
• The surface and its pictorial treatment **p. 34**

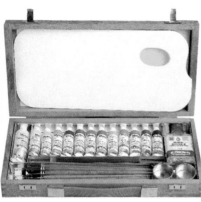

Complete and high-quality travel kit.

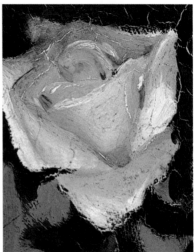

Notice the cracking that has occurred from painting over a layer that was more oily than the later ones.

WATERCOLOR—MATERIALS

Watercolor paint, as the name implies, unfolds pictorially with water. Its basic composition consists of gum arabic and pigment. Watercolor is the best transparent medium and is ideal for painting flowers because its colors are extremely luminous once they've dried and their intensity depends on the amount of water that is mixed with the paint itself.

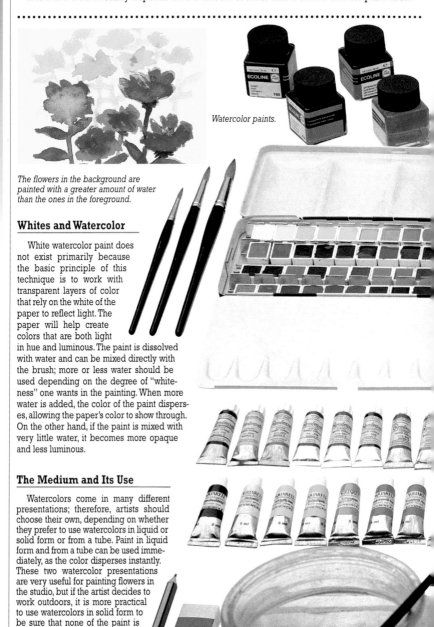

Watercolor paints.

The flowers in the background are painted with a greater amount of water than the ones in the foreground.

Whites and Watercolor

White watercolor paint does not exist primarily because the basic principle of this technique is to work with transparent layers of color that rely on the white of the paper to reflect light. The paper will help create colors that are both light in hue and luminous. The paint is dissolved with water and can be mixed directly with the brush; more or less water should be used depending on the degree of "whiteness" one wants in the painting. When more water is added, the color of the paint disperses, allowing the paper's color to show through. On the other hand, if the paint is mixed with very little water, it becomes more opaque and less luminous.

The Medium and Its Use

Watercolors come in many different presentations; therefore, artists should choose their own, depending on whether they prefer to use watercolors in liquid or solid form or from a tube. Paint in liquid form and from a tube can be used immediately, as the color disperses instantly. These two watercolor presentations are very useful for painting flowers in the studio, but if the artist decides to work outdoors, it is more practical to use watercolors in solid form to be sure that none of the paint is

wasted and to avoid the danger of spilling (something that may occur when using a bottle of watercolor paint).

Bottles and Brushes

Another indispensable item for painting with watercolors is one (or several) plastic bottle(s) to hold water. Any kind of bottle may be used, but plastic is recommended in order to avoid possible accidents. Simply cut the top off of the plastic bottle.

Watercolor brushes vary depending on their use, but for the most part, they should have soft, elastic bristles that are capable of absorbing and applying great quantities of paint or water. The best kind of brushes are sable hair brushes, but high-quality synthetic brushes are also available. When using a fine-tip brush, one should make sure that the tip does not lose its shape with each stroke. Both wide and thin brushes should have high-quality bristles.

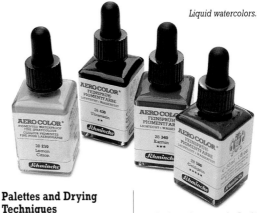

Liquid watercolors.

Palettes and Drying Techniques

Choosing the right palette for watercolor painting requires that the artist decide exactly how he

MORE ON THIS TOPIC
• The surface and its pictorial treatment **p. 34**

Thick and thin paintbrushes that are appropriate for watercolor painting.

or she intends to use it. A white palette is most appropriate, preferably plastic, so that the artist can always clearly see the color of the paint. The palette may have small cups incorporated around the edge that are convenient for using liquid watercolors or for dense watercolors from tubes. The artist can also use palette boxes, especially when painting flowers outdoors.

The watercolor technique requires using sponges or absorbent pieces of paper to eliminate extra water or for creating different kinds of textures. Absorbent paper is more practical because the artist can avoid the risk of staining the work by accident with another color.

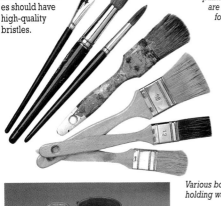

Various bottles for holding water.

Sponges that are appropriate for use with watercolors.

Tools for Painting Outdoors

The Impressionist painters advocated *plein air* painting, or painting outdoors. They enjoyed going into the countryside to capture nature by finding the appropriate subject in its natural environment. Initially, easels and carrying cases were improvised by painters, but little by little, artists have become more demanding in terms of the material they use.

PASTEL AND PAPER

Paper is one of the most versatile surfaces; it allows the artist to develop different kinds of work using any medium. Texture is the main characteristic artists should look for when working on paper, particularly if they intend to use pastel. The paper's texture results from the technique used during its fabrication; its level of absorbency results from the porosity. This last quality makes it possible to use extremely delicate gestures when drawing. During its fabrication process, paper is pasty, making it possible to create any sort of color or grain. When painting flowers, this can be a great advantage, as long as painters are aware of the innate characteristics of the surface they are working on.

On hot press paper the texture of the stroke is not visible.

Hot press paper allows artists to work in great detail.

Hot Press Paper

Hot press paper presents a totally smooth texture and holds lines and gestures in a perfectly uniform way, without any kind of granulation resulting from an abrupt change in the texture. This paper should be used if the artist is drawing with a very delicate technique; it allows color grada-tions to easily be created using the fingers or cotton wads. The kind of work that the artist can create with this kind of paper is usually very pure, but the traces of pastel will also be more sensi-tive to the touch. It will be espe-cially difficult for the artist to paint using thick layers of color because the lack of texture in the paper combined with the loose quality of the medium will make it difficult for the latter to adhere to the paper.

Cold Press Paper

The most frequently used paper for representing flowers is cold press paper because, as discussed previously, hot press paper can be problematic if the artist wants to use thick layers of pastel. Cold press paper has a regular and uniform texture, as well as open pores that allow the pigment to adhere to the sur-face. One of the greatest advan-tages of using cold press paper is the stability it presents when applying thick layers of pastel, and the fact that, depending on the pressure applied to the pas-tel, a textured trace may be left. Cold press paper is useful for blending color and for covering the porous texture completely, but it is possible to use the medium in a way that the paper's texture may show through.

Cold press paper has a regular texture and allows colors to easily be superimposed.

Thick Grain/Rough Paper

There are various qualities of thick grain/rough paper, ranging from the artistically fabricated to high-quality, industrially produced paper. Thick grain/rough paper tends to have a special, abrupt texture that is appropriate only for work where the paper's texture will be significant for the final product. Pastel is somewhat difficult to use on thick grain/rough paper, but it is easy to apply dense layers of the medium to this kind of surface because it adheres immediately to the paper's grain. This kind of paper is not recommended for beginners because it presents many surface irregularities that may make it difficult for the artist to create a uniform trace.

When the work is finished, the texture remains.

Colored Paper

The opaque quality of pastels means layers of color may be applied over one another without the color of the top layers being affected by the bottom ones. This characteristic makes it possible and interesting to use paper that is not white in order to achieve different color contrasts. Using pastels on a background that is not white allows the artist to use even the smallest traces of white and other light colors to signify areas of light or brightness. This is ideal for simulating the effect of light shining on flowers or other objects in a still life composition.

Making the Paper a Rigid Surface

Any kind of paper, no matter how thin it is, can easily be mounted on a stretcher using thumbtacks. This is the best way to create a taut surface on which to paint comfortably. The process is simple: The paper must be dampened with a sponge, and, while moist, a stretcher is placed on a flat surface so that the edges of the paper can be wrapped around it and held in place using a few thumbtacks. The paper will become perfectly flat and taut once it dries.

This is how the paper should be folded while still wet.

MORE ON THIS TOPIC
• The surface and its pictorial treatment **p. 34**

Colored paper allows for the use of white to create maximum contrast.

THE SURFACE AND ITS PICTORIAL TREATMENT

The pictorial surface is the base on which one paints; it can be paper, canvas, wood, sheet metal, or cardboard. Each technique works best on a different kind of surface, adapting to the surface itself and thus creating completely different results, depending on whether the surface is textured or not. In flower painting, the choice of surface is essential.

Pastel on Paper

Paper is the best surface on which to use pastels, although one can paint with this medium on any porous surface. The fragility of the pastel medium makes it more difficult to work with on canvas because the slightest vibration caused by tension will lead to part of the color falling off. Because of its body and texture, paper allows the pastels to be manipulated either with the fingers or with a blending stump.

Pastels can be fixed on the paper using a spray fixative, but many professional painters avoid using this technique, as the color tends to lose its intensity and the stroke loses its vibrancy with the spray fixative. This does not mean that it's not a good idea to fix the first layers of color and thus be able to correct the work during its later phases without ruining the foundation.

The artist should be careful using the fixative; it can ruin the freshness of the work done with this medium.

Pastels can be extended on the paper using the fingers.

Quality gesso for preparing surfaces that will be painted with oils.

Oils are best used on high-quality canvas.

Oil on Canvas or Wood

Oil can be used on any surface as long as the surface has been properly primed or prepared. The most appropriate surfaces to work on using oil paint, however, are canvas and sheets of wood; cardboard and paper will rot over time because of the oil. Canvas can be bought primed or raw; raw canvas must be primed by the artist with one or two layers of latex or gesso before the painting process begins. Wood, like canvas, should also be properly prepared. Note: A properly primed paper will not rot, and so it will be an acceptable surface for use with oils.

Watercolor on Paper

Watercolor should always be used on paper because the paper's absorbency, texture, and composition are crucial to the results achieved using this medium. Paper will make it easier to superimpose various layers of color, creating transparent veils that will benefit from the paper's whiteness in the background. The numerous possibilities watercolor painting allows the artist can be seen only on paper; any other kind of surface either absorbs the water too quickly or rejects it entirely if it lacks any sort of absorbent quality. Watercolor paint will not adhere to a surface that is not absorbent.

There are many kinds of watercolor paper, ranging from heavy grain paper with a pronounced texture to thin paper that is totally smooth.

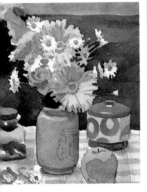

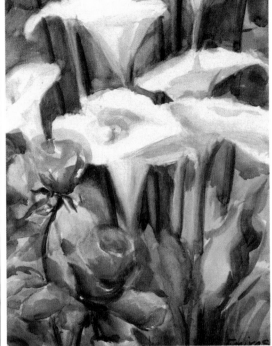

Watercolor on cold press paper.

MORE ON THIS TOPIC
· Pastel and paper **p. 32**

The paper on which these flowers are painted is perfectly smooth, with no grain.

Acrylic on Canvas or Paper

Acrylic paint is the most versatile of all painting mediums. It can be used to paint on canvas or on paper regardless of whether the surface has been primed or not.

The colors are always the brightest and most luminous when the surface has been previously primed with a layer of latex or acrylic medium. One can also add pigment to these priming materials in order to give the background body and color.

Acrylic colors allow for any type of artistic work, and are one of the best mediums to use for painting flowers because they allow for completely flat, opaque, or transparent painting as well as any kind of texture.

After painting on any surface with acrylic paint, the same surface can be used to continue working with oil paint. Note: One should never use acrylic or waterbase paint over oil.

Adding Depth to the Technique

Van Gogh (1853–1890) challenged the painting process in a way that few painters do. He studied technique, his subject, and the quality of his finish very carefully. Based on numerous letters he wrote to his brother Theo, we know that he painted over the same work many times, using different colors and only one subject. Here we can observe his approach by looking at three of the seven sunflower paintings he did.

A—Fourteen Sunflowers in a Vase. *Oil on canvas., Tate Gallery, London.*
B—Sunflowers. *Oil on canvas. Vincent van Gogh Foundation, Vincent van Gogh National Museum, Amsterdam.*
C—Vase with Fourteen Sunflowers. *Oil on canvas. Private collection, London.*

A
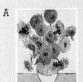

B
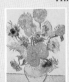

C
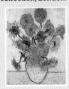

FRAMING AND COMPOSITION OF FLOWERS

The way artists choose to frame their subject regardless of what technique they use is crucial to the composition of the work. When representing flowers, framing the subject matter is not only essential to representing the shapes but is also important because it represents the artist's choice in limiting the space that surrounds the flowers; thus, the artist is determining the proportion of the subject to the space around it. Framing the subject can be as complex a process as the actual composition of the subject.

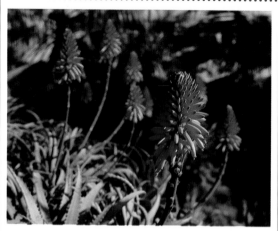

Framing the subject in a larger space allows one to compare the distance and proportion between the elements that make up the subject.

In this example, the framing may lead to a disproportionate subject.

Framing and Proportion

Framing is the part of the process that relates the subject to the limits of the surface on which it is depicted. Framing the subject means deciding what part of it is going to be included in the work, in other words, whether it will be represented in a way that allows it to fit entirely in the surface area, or if it will be presented as a detail. If artists choose to represent only a detail of the subject, they will have to determine how much space to include around the detail. If you give maximum attention to a flower or a plant while disregarding all or part of the background, you may end up with a disproportion of forms since the viewer will have no reference point with which to compare the subject.

The Subject and the Space Framed around It

Artists may capture the subject in many different ways. When they decide to frame the subject, they are determining the proportion of the subject to the space surrounding it as well as the balance between the space surrounding the subject and its mass.

The artist should learn to observe a subject that is composed of more than one element

as a single mass; then the criteria for choosing the space to surround the subject will be objective. If the subject is understood as a compact object, it is much easier to frame it appropriately in order to achieve balance in the work. If the subject is understood as a compact object, it is much easier to frame it appropriately in order to achieve balance in the work. A small frame made of Bristol board will allow the artist to observe the subject and frame it according to the desired format.

The framing can be symmetrical (A) or off center (B).

A B

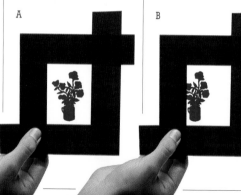

A—Using the axis of symmetry to determine the framing will lead to an unbalanced relationship between the focal point and the rest of the objects.
B—Moving the axis too far away from the main figure in the composition will create a feeling of imbalance.
C—As one can see in this example, the appropriate framing of the subject matter means the main figure is slightly off center.

A B

Resources for Framing

A good criteria for framing the subject is remembering to establish a balanced relationship between the subject and the format chosen to work with. Contrary to what may seem obvious, the center of the line that symmetrically divides the subject is not usually the best place to begin determining the balance. Often, this criteria for framing the subject has adverse results, for the subject tends to be much more complex in terms of colors and shapes. The subject should be balanced against all the different elements included in the composition, so that the overall effect is more interesting and dynamic. A good way to determine the balance is to divide the focal point of the composition between the main element and a small part of the background, placing the subject slightly to one side of the central axis.

C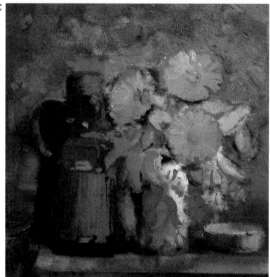

Resources outside the Studio

When one decides to paint outdoors, the subject that is chosen usually has a large margin of ambiguity regarding the framing and the arrangement of the different floral elements. It is adequate to use a small frame made of paper or cardboard to choose the appropriate area to include in the composition. Photographs will allow the artist to obtain images that can be elaborated on in the studio and, better yet, instant photos are useful for obtaining an immediate image of the composition.

An example of a break at the surface's outer limits.

The Limits of the Area

When choosing the best way to frame flowers it is very important to keep in mind where the physical limitations of the surface lie. One must not think of the painting as ending where the edge of the surface is; instead, the work should be thought of as a window that allows one to see only part of what lies behind it. This implies that one can choose to frame the composition so that only a part of the subject shows while the rest lies hidden behind the painting's limits.

| MORE ON THIS TOPIC |

· Lighting and the subject **p. 24**
· Preparing the subject **p. 26**

COMPOSITION AND STRUCTURE

Every element in nature has a specific shape that can be reduced to a simpler, more basic shape that makes it easier to understand and structure on the canvas. The practice of painting flower themes begins with understanding that there is no such thing as a complicated subject. The only way the subject may be seen this way is if the artist does not fully understand it. The key to creating a good composition is realizing that basic shapes can easily be represented by reducing the structure of the subject to simple geometric shapes.

Order in Space

The structure of the objects that make up the floral composition should be balanced harmoniously against the other elements in the composition, including the space that surrounds the subject. The basic lines of the subject always translate into a geometric structure, allowing it to be arranged in the painting without having to depict details and each one of its shapes. The composition should always be approached starting with the general aspects before going into detail. Understanding the structure of the subject will create a firm foundation that will be very useful for the future development of the painting; it is essential that the artist understand the composition's geometry in terms of space. The space that the painting intends to illustrate should be considered carefully from the beginning; only in this way will the composition be successful.

The Basic Shapes

The basic shapes of the subject translate into geometric shapes that are found throughout the space of the painting. For example, a handful of flowers can be seen as circumscribed by a circular mass that can then be placed in the painting as the artist desires.

An interesting characteristic of many paintings that are considered great masterpieces is that they tend to stick to two basic shapes in their compositions: a circle or an ellipsis, and a triangle or a rhombus. Once these basic shapes find an appropriate location in the space of the painting, their placement becomes of greater interest due to the subject's basic compositional lines, which center the viewer's attention on the desired shape. Finally, it is important to note that one of the most significant shapes that forms part of the structure of the composition is the trapezoid in all its variations.

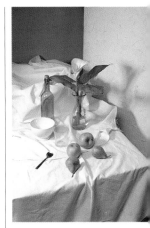

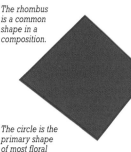

The rhombus is a common shape in a composition.

The circle is the primary shape of most floral compositions.

MORE ON THIS TOPIC

· Preparing the subject **p. 26**
· Framing and composition of flowers **p. 36**

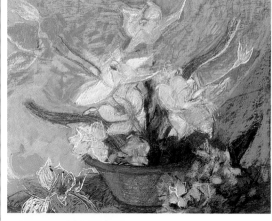

The triangle is one of the most interesting compositional shapes.

Looking for the Compositional Lines

After structuring the basic shapes of the painting, it is very important to analyze the rhythm of the different elements' placement in the composition, in other words, the placement of the various shapes that make up the model create a series of lines that "freeze" the location of the shapes within the painting. These lines will serve to create a more interesting composition. In fact, when the subject has no such lines, these can be interpreted by the painter with the intention of increasing the weight of the painting's composition.

The lines that form the structure of the space included in the painting follow both a broken and a continuous trajectory.

This figure exemplifies the prominence of a diagonal composition.

A Masterful Example

Van Gogh, one of the most significant Postimpressionist painters, aside from his pronounced brushstrokes and rotund forms, was known for the emphasis he placed on the compositional aspect of his work. One has only to observe his masterful painting *Irises,* in which he developed a "weaving" of diagonal lines composed of different masses of color. It is interesting to note how the vertices coincide with the gold area of the painting.

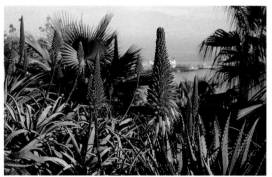

Observing the Subject

Observing the subject is very important for the study of the compositional structure of the work and the linear rhythm of the shapes. The painter's analysis of the subject should be apparent in the work from the beginning through the synthesis of shapes, from complex to simple. The first element to consider is the total space the painting will include, followed by the volume of the main shape, and, finally, the individual shapes that form part of the main volume. During the observation of the subject, the painter should discern what shapes are essential to developing the painting and which of these can be ignored. This process will help the artist achieve the desired balance using only those elements that are of interest.

PLACEMENT AND APPROXIMATION THROUGH DRAWING

Drawing is a necessary step in every artistic process and its purpose is to create a simple structure, which will become more specific as the lines begin to find their appropriate place. Placing the different elements in the painting is a preliminary process, necessary to fit everything into the space of the painting. Flowers and plants are complex structures that require the different elements of the subject to be in their correct place, and by taking the time to consider the placement of these elements, the artists can easily solve any doubts they may have regarding their structure.

•••

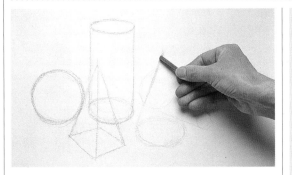

The study of geometric shapes will help the artist understand volumes in the painting.

Geometry

Drawing shapes using a purely geometric language is an interesting way to better understand three-dimensional structures or volume. Flowers are shapes that have been very carefully structured by nature. Their planar composition is based on very exact structures, with superimposed petals that give way to very precise geometric bodies. For this reason, it is very useful to practice drawing flowers as geometric shapes and thereby learn to translate reality into a two-dimensional realm on paper. This first exercise of placement will be useful for the future development of far more complex structures.

Axes and Placement

To begin placing the elements using drawing, it is convenient to establish certain axes for situating the subject. The vertical axis indicates the relationship between the subject and the center of symmetry of either the paper or the

painting. The horizontal axis allows one to establish proportional relationships between the elements that fit into each one of the four sections created by the axes of symmetry. It is not necessary to mark the axes very obviously; they are nothing more than a useful guide during the initial process of placement. It is easier to situate the basic lines that will be used for placement purposes once the initial axes are drawn as guidelines. The axes will help the

From Generalities to Detail

The placement of flowers in a pictorial space always has to be approached generally before focusing on detail; in other words, the entire volume of the flowers must be treated as one before focusing on details that may detract from their basic shape. When the basics have been established, the artist may begin to focus on smaller shapes, while still avoiding the smallest details. Once the composition has been sketched, the placement of the entire volume should be reconsidered in order to make corrections on shapes and to specifically place the smallest elements in the painting, possibly the flowers.

artist understand how the subject fits into the pictorial space while making the proportions of the main lines become much more tangible.

Two axes have been traced that will serve as guides to the placement of the subject.

The shapes of the plant have been precisely defined over the axes.

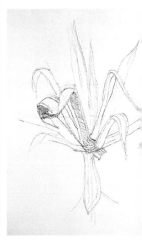

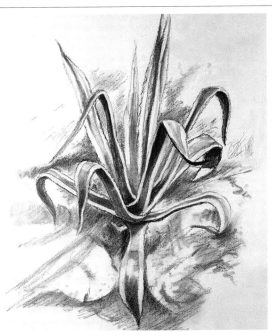

If the original placement of the subject in the pictorial space is good, finishing the drawing will be simple.

Practice: Developing the Shape

After having established the initial lines, the shapes can be placed in the pictorial space with much more confidence since the main structure serves as a guideline for their configuration. For example, the leaves of a plant can be initially outlined this way, but their volume will not be apparent until the artist begins to use shadows and dark lines. The drawing of the plant begins to take volumetric shape only after it has been correctly placed in the pictorial space. The rest of the process should not be complicated if the artist has already taken care of the placement, and, in fact, it will be easier to develop a drawing based on a sketch than without using some kind of previous structure to guide the lines.

The details of a flower take shape starting from a geometric sketch and using gesture drawing.

Gesture Drawing

Fitting the shapes of a plant into the pictorial space does not always have to be done on a structure of lines or polygons. An alternative to placing the drawing in the space requires paying closer attention to the proportions and the planes of the plant. This means treating the process of placement directly as a drawing. After preparing with a geometric sketch that describes the main elements, a quick drawing will serve to place the main shapes. These shapes will become more defined during the process of placement of the subject. Corrections can be made during this process, redrawing the shape using lines and washes, and erasing until its precise location has been established.

The placement of the subject can always be corrected with new lines or washes.

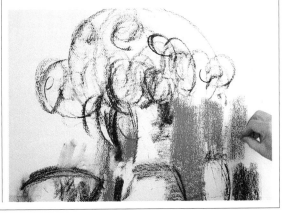

MORE ON THIS TOPIC
- Preparing the subject **p. 26**
- Framing and composition of flowers **p. 36**
- Flowers with pastels **p. 54**

DRAWING FLOWERS WITH INK

Floral still life painting is a wonderful theme to work with while learning how to paint and investigating composition. Drawing is the starting point for all pictorial themes. Structuring the subject, as well as placing its elements correctly within the painting using drawing as the technique, allows the artist to work on the subject matter while studying the location of its planes and defining shapes through different contrasts. Ink drawing challenges the artist to reduce the different shades of color to simple washes, and shapes to simple structures.

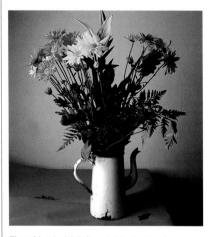

The subject is rich in lines, but its structure is simple and defined.

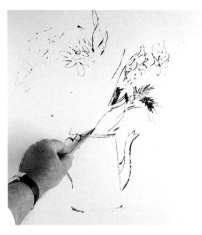

Drawing directly on the paper without using a sketch means correcting errors as they occur.

Direct Placement of the Subject

Drawing with ink means the artist can place the form directly on the surface without resorting to a previous sketch, as the strokes that are slowly laid on the paper can immediately correct all possible defects. Of course, creating a clean drawing from the beginning is something that requires a lot of practice and mastery of the drawing technique on all levels. Drawing with ink can be done with a small feather or a bamboo stick—both leave a characteristic mark and should be dipped in ink every time they run dry.

Drawing with Bamboo Sticks

If the artist wishes to use a bamboo stick as a drawing utensil, it should be thin, perhaps the size of a finger. The bamboo should be beveled to create a

A broken line is only one of the many possibilities one can achieve using a bamboo stick.

sharp tip with a longitudinal incision at the end that will ensure the canalization of the liquid. Bamboo already prepared for drawing is available at art supply stores.

Flowers drawn with bamboo characteristically present a broken and irregular line. Gray areas can be created by drawing when the ink has almost run off the pen. Thick and uniform lines can also be created by breaking off the

instrument's tip. Of all the instruments used for drawing with ink, one can create the greatest number of variations in line using a bamboo stick. The bamboo should not be wet too much in the ink or else it may flood on the paper. Also, the line should be soft and fluid, without putting too much pressure on the instrument.

Resources for Drawing

Any tool used creatively can be a good drawing utensil. The artist should not only experiment with commercial materials, but should also investigate the quality of line that can be created using everyday materials as drawing utensils. A fork, for example, is perfect for creating parallel, uniform lines; an old marker may help the artist achieve a rubbing effect; and a sponge allows all sorts of marks.

Chromatic Addition

Working with ink allows for a great variety of finishes. Many artists choose to work only with black, but the possibility of working with colors or watercolor should always be kept in mind. Any mark made with permanent ink will be stable as soon as it dries, providing a good base for working with transparent aniline dyes, colored inks, or watercolors. The process requires using water to thin down the mediums, and because the layers are transparent, they can be applied over the initial drawing without affecting it. As a result, the white paper will be stained with color.

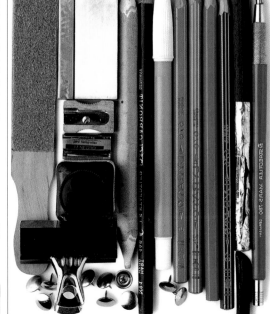

Color can be added to a drawing using ink or watercolor.

Colored paper allows the drawing to be highlighted using white and sanguine conté pencils.

Drawing Material

There are an incredible number of drawing mediums that can serve to complement the work that has already been done with ink. Usually, the adequate combination of different drawing tools will allow the artist to achieve singular results. The kind of paper the artist chooses to work with will be the first factor; it will provide an initial and specific, uniform, chromatic base to draw on with any color but black.

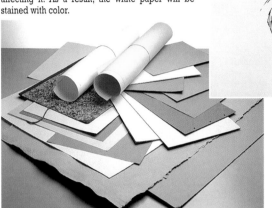

Various drawing utensils that can be used for working with ink.

MORE ON THIS TOPIC
· Watercolor—materials **p. 30**
· Sumi-e flowers **p. 64**

CONTÉ: SANGUINE AND SEPIA

Some techniques allow the artist to study the subject based on lines and washes of color that suggest volume and are also useful for creating an initial sketch. Sanguine and sepia conté crayons and pencils are made of minerals that have been agglutinated with tragacanth gum using water. The compatibility of these two different pencils allows the artist to combine them to create a wide range of colors that will be very helpful for the study of flowers. The medium allows the artist to easily extend the pigment over the paper's surface in order to create color gradations and mixes that will give the drawing a sense of volume.

The artist has chosen to light the subject from the side in order to create contrast between its different elements.

The Placement and Study of the Subject

Selecting the appropriate lighting for the model is important because it will determine the quality of the contrasts of the shapes of the flowers, the vase, or the book.

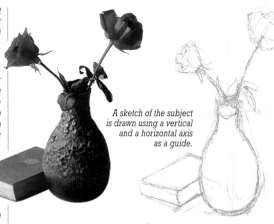

A sketch of the subject is drawn using a vertical and a horizontal axis as a guide.

Placing the shapes in the pictorial space requires using a vertical and horizontal axis as a departure point. These axes help the artist place the various lines that pertain to the model's structure; the lines themselves can be drawn using the sanguine conté.

Suggesting Volume

Once the sketch has been perfectly resolved, the sanguine conté crayon can be used to

The sanguine conté crayon is used to suggest the different tones of the flowers.

begin drawing the shapes of the rose. The artist should begin by creating a few marks using small lines that will suggest the darker areas; the lightest parts of the petals should be left totally white. The drawing should always be approached using soft strokes. Pressure on the conté crayon can be increased in the areas where the shadows are darker. One of the possibilities that all dry mediums share is that

they can be fused or blended together using the fingers. This particular technique should be used to suggest the flower's volume, in other words, by dragging the pigment with the fingers once it's been directly deposited on the paper, the artist can begin to give the flower its exact shape.

Fingers can be used to easily shape the flowers.

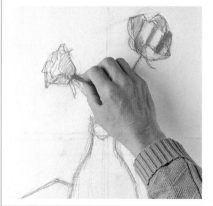

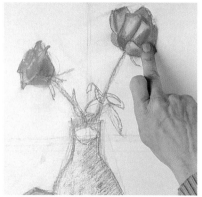

Shading

After outlining the dark and light areas, one can proceed to outline the areas where shadows increase or decrease in order to show texture and contrast in the different areas of the model. The artist may begin by using light lines over the initial description of tones, this time using the sepia-colored conté, which is much darker than the natural sanguine color. In the same way that the medium is blended to suggest the shape of the flowers, the color should be softly blended to develop the shape of the vase. The darkest areas should show the densest color, as opposed to the lightest, which can range from soft tonalities to no color at all.

MORE ON THIS TOPIC

- Pastels—immediate color **p. 46**
- Oil pastels, line and shadow **p. 48**
- Flowers and birds **p. 52**
- Flowers with pastels **p. 54**

Sepia conté is used to draw over the shape of the vase, adding depth to the shadows.

After having blended the medium with the fingers to create shadows, whites are created using an eraser.

Texture and Contrast

Because white is not used as a color, the light areas are defined by the amount of background white the artist chooses to let show through. It is also very important to create volume using shadows that follow the direction of the plane they lie on. For example, if the flower's petals are concave, the shadows should follow this same direction. This can be achieved using the fingers; ultimately, light and shadow will be created that logically follow the planes of the subject.

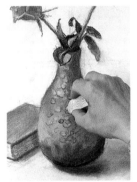

An eraser is useful for creating light and texture.

An Ancient Medium

Sanguine conté is made of a specific kind of red earth known as iron oxide, a soft mineral that, when pulverized and compacted with glue, produces this medium. It is characterized by the earth-red tone it produces. Sepia-colored conté, on the other hand, is extracted from the ink sacs of certain cephalopods.

Sanguine is one of the most ancient drawing materials; it was used by the Romans to prepare tablets and also for mural painting.

PASTELS—IMMEDIATE COLOR

Pastels are a somewhat unfamiliar medium to most amateur painters; however, many professionals have dedicated a large portion of their careers to cultivating this artistic medium, especially artists who focus on representing flowers. Pastels allow the painter to "paint" by drawing, and to draw by painting using a totally pictorial process. As opposed to any other artistic medium, pastels were in great competition with oil paints during the eighteenth and nineteenth centuries.

Placement through Quick Washes

Placing the model in the pictorial space using pastels can be done quickly using soft, linear strokes that will fit the main elements on the paper. The purpose of the general drawing that now follows will be to situate a series of immediate washes of color that will give shape to the volume of the flowers. It is extremely important that the artist be conscious of where he or she places the main lines, for they will serve as the basis on which the rest of the drawing will be built; in other words, the accuracy of all other gestures will depend on these initial lines.

The placement of the elements in the painting will be done directly using the pastel stick. The artist should attempt to suggest the volume of the bouquet and the objects that surround it, such as the vase or the drapery.

Dry flowers provide an excellent subject for drawing with pastels.

Quick washes are used to suggest the volume of the flowers.

The placement of the shapes is done globally, taking the entire group of flowers into account using one single line.

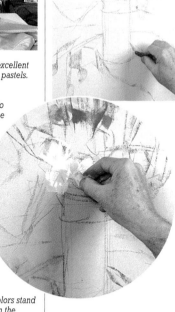

Light colors stand out from the paper's darker background.

White on Colored Paper

Pastels are a completely opaque medium, which means that light colors can be used over darks, and also to draw on colored paper. This characteristic is something that pastel artists always take advantage of, creating an intense feeling of light through the unabashed use of light colors and whites. If the paper is no more than a light gray, whites will appear to be extremely luminous. Using colored paper can be to the artist's great advantage, especially if the artist is working on a floral composition, for the subject will have a greater sense of unity if the background is not filled in and if small areas of paper show through and create an interesting contrast with the more luminous colors.

Painting without Mixing

Pastels should not be mixed together, for the colors will always be far more interesting if they are applied directly on the paper. This does not mean, however, that one color may not be blended with another, although it is recommended that this procedure be kept to a minimum. Pastels are partly made of chalky lime (white), and the colors will tend to lose their freshness and luminous quality the farther they are spread over the paper's surface.

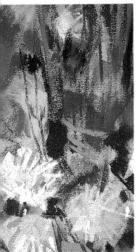

The gray of the paper shows through the colors that have been layered on it.

Color Theory and Superimposing

Color theory states that color does not vary in tonality according to light, but rather that the colors of an object are independent from each other and do not have tonal variations. With this theory in mind, one can create a

Color theory suggests using pure colors, such as the ones used to draw these flowers.

painting of flowers that is spontaneous and direct, without having to consider the range of variations that exists in one color. For example, a yellow flower can be depicted using energetic strokes of color, while pure orange may be appropriate to define the darker areas.

Another interesting approach to painting is superimposing tones and colors using pastels as a medium. Because pastels are perfectly opaque, the artist can place several layers on top of each other without having to worry about them mixing. To

MORE ON THIS TOPIC
• Conté: sanguine and sepia p. 44
• Oil pastels, line and shadow p. 48
• Flowers and the figure p. 50
• Flowers and birds p. 52
• Flowers with pastels p. 54

ensure greater stability for the bottom layers, a coat of workable spray fixative can be used.

Color Contrasts

Flowers can be seen as areas of color that, if approached individually, may not appear very interesting, but, by using contrasting colors, the artist may create incredible areas of light. A warm color placed next to a cool one will appear much warmer and luminous, in the same way that a dark color placed next to a light one will make the light one seem much brighter.

Increasing the number of cool colors (blues) brings out yellows and reds.

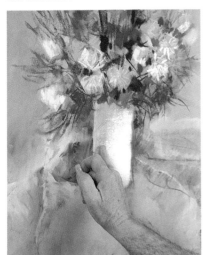

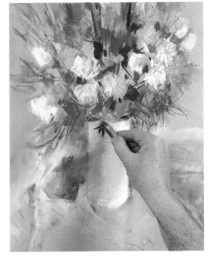

OIL PASTELS, LINE AND SHADOW

Pastels are a totally dry medium, unstable to the touch, yet extremely luminous and with a great variety of technical possibilities. Oil pastels are nothing more than this same medium mixed with oil, as the name implies. Although similar in appearance to conventional pastels, oil pastels are much more solid to the touch and allow the artist the possibility of applying thick, dense layers of color, mixing them with oil paint, and diluting them with mineral spirits.

The Alternative Medium

Oil pastels allow the artist the versatility of dry pastels along with the range of possibilities of an oil-based medium. This hybrid medium is ideal for the amateur painter to delve into the pictorial experience and practice painting directly and intuitively, the way one would using dry pastels. As an artistic medium, oil pastels are very practical for painting flowers because they allow the artist to alternately mix and dilute colors. The medium also allows the artist to finish the work using line drawing or intense color mixtures. Because oil pastels can be dissolved with mineral spirits, oil pastels allow the artist to work using a brush and creating very liquid and transparent colors that will tend to dry quickly.

The Possibility of Drawing

Oil pastels allow the artist the possibility of drawing in a traditional fashion and coloring these drawings in the same way one

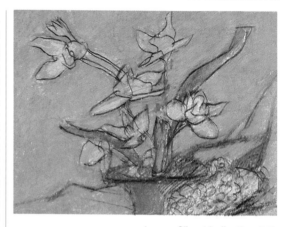

would if using dry pastels. Drawing can be done spontaneously, creating a general sketch that will become more defined as the placement of the objects becomes clearer. Oil pastels, however, have a smoother texture than dry pastels, and, therefore, mixing them on paper creates a sumptuous, dense color that will allow the artist to produce a clean drawing and superimpose completely pictorial layers of color.

Oil pastels allow the artist to alternate between a traditional drawing method and pictorial washes of color.

Oil pastels also make it easy for the artist to sketch the subject quickly, without the complications that arise when using encaustics, colored pencils, or pastels.

The dense application of color allows the bottom layers of color to breathe.

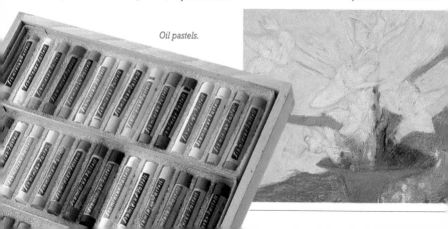

Oil pastels.

Scratching with the tip of a brush can be an interesting technique for working with heavy layers of oil pastel.

A brush wet with turpentine allows the artist to fuse colors directly on the surface.

Fusing Colors Using Turpentine

Once the first layers of color have been placed on the surface, the painting will have a certain body that can be developed using turpentine and a brush. After wetting the paintbrush with turpentine, the artist should experiment by brushing over the painted surface. The paint should instantly become liquid allowing the artist to apply it by using different kinds of brushstrokes. It is more interesting, however, to alternate brushstrokes and lines drawn with the medium; because the colors tend to easily fuse together, they can be mixed directly on the painting surface. This technique produces very interesting effects, because you may play at obtaining colors that are different from those that are already drawn; for example, if you have drawn a green line on the side of a red line, the combination will give you an earth color.

Drawing directly on the painting gives the work a fresh, loose quality.

Combining Techniques

Oil pastels allow the artist to work with an infinite number of techniques on the same surface. Flowers can be painted or drawn at the same time, as oil pastels allow the painter to quickly and spontaneously alternate between these two methods. The artist may also superimpose completely graphic elements on areas that have been previously blended.

Technical Compatibility

It is very important that painters familiarize themselves with the possibilities that all the different mediums allow for mixing, and thus be able to refer to them at any time. It is possible to paint with oil pastels over acrylics, tempera, ink, and watercolor, but not over oils; oil paint and encaustics, however, can be applied over oil pastels, but not on anything else.

MORE ON THIS TOPIC
· Conté: sanguine and sepia **p. 44**
· Flowers and the figure **p. 50**
· Flowers and birds **p. 52**
· Flowers with pastels **p. 54**

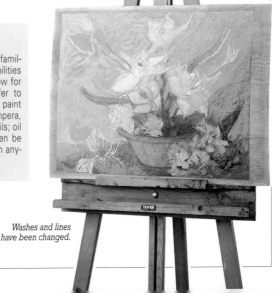

Washes and lines have been changed.

FLOWERS AND THE FIGURE

Flowers often show up in all kinds of paintings, sometimes as a purely decorative element, and other times as an intrinsic part of the composition. Before Caravaggio's first still life painting, flowers were never seen as separate from the primary genres of painting: portraiture and landscape. Flowers enliven any kind of painting, not only because of the color they add to the composition, but also because they add interest to the composition of the work. It is very important for the artist to know how to establish the right equilibrium between the different elements of a painting that involve both flowers and the figure.

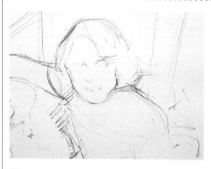

The shape that suggests the bunch of flowers should be present in the initial sketch, together with the figure.

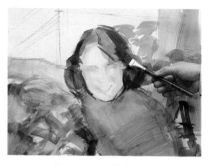

The green tones lend unity not only to the dark tones, but to the entire composition.

The Placement and Distribution of Mass

The focus can either be equally distributed among each of the elements that form the painting, or the artist can choose to emphasize only one of the themes.

To develop either of these ideas, the artist will have to take into consideration the placement of the different elements in the picture. The placement of the floral shapes should be established from the beginning even if the figure is supposed to play a dominant role in the painting. Simple shapes, based on lines, will help describe the main volumes in the painting, and are the best way to approach the distribution of the various masses in the space. The initial sketch should outline what will eventually be the bunch of flowers along with some of the more dominant volumes that make up the composition.

MORE ON THIS TOPIC

• Pastels—immediate color p. 46
• Oil pastels, line and shadow p. 48
• Flowers and birds p. 52
• Flowers with pastels p. 54

Balancing Color

If different thematic elements are going to be present in the same composition, it is important to make sure that they don't appear to be cut and pasted. The composition should present a harmonious balance of color between the different elements in the painting. One color should dominate the composition in order to lend coherence to the work. For example, if the floral composition presents some green tones, these may also be used to create shadows in the figure, or perhaps one particular color can be chosen to be present in all aspects of the painting.

The background color of the paper breathes through the painting.

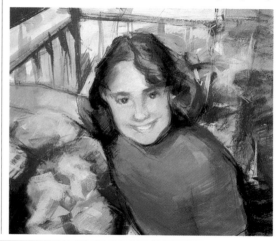

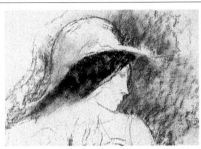

The floral composition is painted independently of the figure that accompanies it.

The background has been darkened using sienna as a color, allowing the figure's profile to stand out.

Working in Phases

A painting can be developed using both flowers and figures as the two dominant themes, without giving them the same character. The artist can achieve this by painting the floral elements first and the figure last, but this process implies taking certain risks, for the painting may lose coherence with regard to color, resulting in an incoherent relationship between the different elements in the painting.

Once the flowers have been developed, the figure may be integrated into the painting. The artist must begin by defining the background color, making sure that it is a color that can later be incorporated into the floral elements of the painting.

The figures flesh tones have been matched in certain areas of the flowers.

Resources

It is important to always think of color as the unifying element between the various parts of a painting, regardless of what technique is used. A good way to integrate various elements into a composition—in this case flowers and a figure—is by allowing them to share the same color and light. In other words, if one color is common to the various elements,

it will serve as a unifying element. For example, the color that forms the background shadow may also serve to depict shadows in the flowers. Coherence among the various planes in the painting will result from taking this approach to color.

The Image File

Every painter should have access to a number of images to paint from, regardless of whether he or she prefers to paint from nature or from a photograph. Furthermore, the artist's file of images does not necessarily have to include photographs, but may simply consist of reproductions of flower paintings. Using reproductions can be very useful for the artist to understand the various techniques other artists have used to solve issues of texture, mass, and light.

FLOWERS AND BIRDS

Two elements that have always coexisted in painting, and that are truly relevant to each other, are flowers and wild birds. This is not only due to the fact that these two elements coexist in nature, but also because they each create interesting aspects of color in painting. There are a great number of painting techniques that tie birds and flowers together, but the main concern should be creating a good balance between these beautiful, delicate forms.

A quick sketch of a bird on a branch.

The simplest shapes serve to suggest the more complex ones in an accessible manner.

Distributing the Elements

When depicting flowers and birds in a painting, it is important to be conscious of the way one distributes the elements of the composition, for the mass of the bird plays a smaller part in proportion to the mass of the flowers.

The balance between the different objects in the composition will depend on their placement. Each mass will give the area in which it is placed a different sense of weight; in other words, the weight of the birds, as masses of color, should be complemented by the volume of the flowers in order to create balance. The overall result of taking these elements into consideration to achieve balance is the creation of an interesting composition with a decentralized focal point, giving rhythm to the placement of the shapes.

Simple Solutions for Complex Shapes

The elements that appear to be the most complex can always be solved in a simple manner. Reducing complex elements of the composition to simple geometric shapes allows the painter to synthesize these elements. Most bird shapes can be reduced to ellipses and ovals, creating a sketch of two circular elements that can further be developed to represent two birds perched on a branch. Although sketching forms is a simple process, it is necessary that the painter continue to observe the subject at all times, in this case, the exquisite shapes of the birds.

Washes and Color

Once a sketch of the different elements has been created, regardless of the technique, the artist can begin to give them a sense of mass. The initial structure, whether it is made up of branches or any other linear elements, will serve as a foundation for the development of the work. Certain techniques, including

The composition is balanced by giving the focal point a decentralized position.

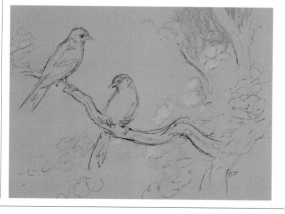

MORE ON THIS TOPIC

- Pastels—immediate color **p. 46**
- Flowers and the figure **p. 50**
- Flowers with pastels **p. 54**

The birds and the flowers are added to the composition once the branches have been perfectly defined in the space.

pastels, oils, and acrylics, allow the artist to superimpose washes of color; watercolors, however, require that the light areas be left intact, for the work depends entirely on the use of transparent layers. If the artist has created a solid initial structure—a sketch of branches for example—it is easy to place the birds or flowers.

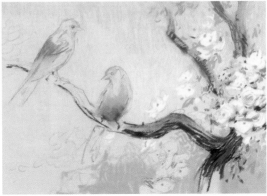

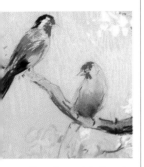

New colors and shadows give shape and contrast to the forms.

Purity of Form

Once the washes of color that define the main structure of the painting and the distribution of color in the shapes have been defined, the artist may begin complementing these by using different colors in order to create volume. Using dark and light colors, or allowing the background color to show through, will help create the sense of mass. Purifying the shapes means departing from a general perspective and focusing on details by tackling the smallest nuances in color and light at the end.

Color and Detail

The various colors that define the texture of the subject can be added as soon as a solid foundation of color has been created. Small touches of color can be painted on top of the larger areas of color to finalize creating a structure for the shapes and defining

their relationship to the source of light. A brightly lit object requires a greater number of colors than one that is hidden in shadow. Flowers can be developed by creating washes of color to suggest their shape, followed by small areas of color placed in their center, and greenery to bring out their shape and create contrast. The final details have the purpose of creating contrast. This is achieved using small additions of color that further define the shapes of the flowers, birds, or branches.

Detail of patches of color.

Flowers Everywhere

Flowers can accompany any style of painting, giving it a touch of elegance and refinement. During the French Academy period, flowers were of such great importance as a complementary element that the majority of painters included them in their work, regardless of whether the style was portraiture, mythological, or historic.

François Lemoine (1688–1737), Head of the goddess Hebe. British Museum, London.

Fresh lines and fused colors have been combined.

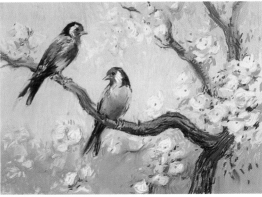

FLOWERS WITH PASTELS

Drawing allows the artist to create shapes and give them a sense of volume using a scale of gray tones. Pastels have similar characteristics to charcoal, for they can be used without a medium and can be manipulated with the fingers. Pastels have many things in common with other drawing mediums, especially the way one uses them to create a sense of mass; however, they are considered a painting medium. Pastels may be considered a link between drawing and painting, and can be used to create the same effects one can achieve by drawing.

Suggesting the Shape of the Subject

Using colored paper as a surface, one can begin to place the objects in the pictorial space in the same way one would when using charcoal as a medium. The lines should be simple and steady, and should make a general description of the subject's shape. The artist should approach this part of the process as a sketch and ignore all elements, such as shadows and other details, that will be developed at a later time in the painting.

Pastels and charcoal can both be used to create wide marks (using the sides of the medium), or as pencils to draw thin lines. The placement of the shapes

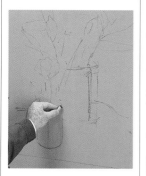

For the initial sketch, the pastel stick is used as if it were charcoal.

should be done using the side of the pastel, and lines should be used for more precise work.

Background Color and Washes

Pastel is a completely opaque medium that can be manipulated with the fingers or used directly.

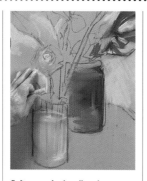

Soft areas of color allow the paper to show through in the background.

Because pastels are dry and soft, they can be blended and mixed very easily directly on the surface. This is helpful for creating general areas of color that suggest the model's shape. The initial color should be soft, extending with the finger the marks left by the pastel stick. The background color should be allowed to show through at any place that is appropriate; in other words, the blended color should not cover the entire surface of the paper.

The shapes can be further defined by applying color directly and without blending.

Using the Fingers

Pastels are not applied with paintbrushes but rather with the fingers. This allows the artist to blend the medium and manipulate it by applying different amounts of pressure. Depending on the amount of pressure put on the pastel, the color may totally cover the surface of the paper or leave some of it untouched. Using this technique, the artist can depict flowers that are rich in both color and texture. First, the fingers blend the color, creating an almost transparent, veil-like background. A second layer of color allows the artist to establish which areas should receive the most light. Blending the color once more helps to define the shapes, and, finally, a few touches of color applied with the little finger will increase brightness in the areas of light.

MORE ON THIS TOPIC

• Pastels—immediate color **p. 46**
• Oil pastels, line and shadow **p. 48**
• Flowers and the figure **p. 50**
• Flowers and birds **p. 52**

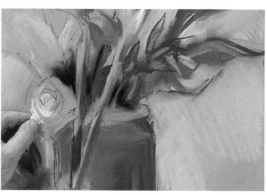

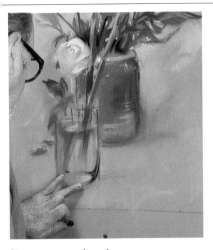

Fingers are commonly used when working with pastels.

Layers of blended color are alternated with direct, unaltered lines.

Blending and Layering

The development of the painting requires the artist to pay special attention to whether or not the colors should be blended once they have been applied to the painting surface. Pastels are the freshest, most direct medium to work with, but if the painting is done using nothing but colors that have been blended, it will lose its grace and spontaneity. Blended colors should be used alternately with untouched gestures. The unaltered use of the medium will help the artist create a sense of bright light on certain objects in the painting, for example, the light reflecting on the ceramic, and a velvety texture resulting from light falling on the leaves and petals.

Using a Spray Fixative

The spray fixative should be used

very carefully on pastel paintings, as it tends to compress color and detracts from the freshness of the final product. However, it is possible to use it during the painting process to fix the initial layers or those the artist wishes to keep intact before proceeding to add more layers of color. When using a fixative to isolate layers of pastel, be sure the fixative is a workable type.

The effect of light is created by applying dense layers of pastel over the blended areas.

Notice how the dense layers of color have been alternately used with blended color.

ACRYLIC STILL LIFE PAINTING

No other painting medium is more versatile than acrylic paint; it can be used to work with any kind of subject matter and produces both opaque and transparent finishes comparable to those produced by other mediums. Acrylic paint can be manipulated in many different ways to create dense or transparent layers, and colors that are either perfectly flat or that can be used to shape mass. If the artist wishes to use transparent layers of color, acrylic paint can be perfect for superimposing sheer colors.

Mixing Acrylics

Acrylic paint allows the artist an infinite number of possibilities with regard to color. This medium dries very fast to form a transparent layer that seals the pigment. Acrylics hardly vary in color once they are dry and are the best medium for fast mixing and attaining immediate coherence with color. One needs to apply only a small quantity of paint to the palette, and mix it with another small quantity of paint to achieve a completely new color. The colors the artist can create using acrylic paint are just as beautiful and interesting as the ones created using oils. Acrylics will thus allow the artist to fully develop all aspects of color and light when painting flowers.

The Initial Sketch

The subject should be studied initially through drawing in order to understand its relationship to the space that surrounds it. It is important to keep in mind the technique that will be used for the future development of the painting, for example, if transparent layers are going to be used, etc. This will determine whether the artist should create a strong initial sketch or whether it should serve simply as a

Acrylic paint is easily mixed to produce rich colors.

guide throughout the development of the painting, particularly if watercolors are used. If the initial sketch is poorly drawn, the painting that results from it will probably be worse. In order to avoid this, the artist should always pay careful attention to the initial sketch, even if it requires a great deal of time. In this example, the drawing that was used was perfectly clean and linear, ignoring all burdensome details.

The subject is simple both in shape and composition.

After creating a transparent background, the flowers are painted with a pure color.

The colors used to paint the flowers are opaque and can be applied directly over the background without affecting the new color.

Opaque and Transparent Painting

Acrylics can be applied either as very dense or very transparent layers of paint, depending on how they are mixed on the palette. A flower painting, such as the one that is being developed here, requires that the artist alternate these techniques in order to create an image that reflects light while appearing fresh and spontaneous. The best way to create

transparent layers of color is to blend the paint with water directly on the palette, or even better, by adding acrylic medium.

Thinning down the paint allows the artist to paint over another color, in this case the white paper, so that this base surface shows through and reflects light. The background should be painted using a transparent layer and alternated with opaque spots of pure, light color to create the flowers.

Superimposing Colors

Acrylic paint is a medium that dries quickly, allowing the painter to alternate different layers of color, both opaque and transparent, during one session. The placement of the different layers of color should follow the structural composition of the painting. Also, the artist should remember that a transparent layer of color can be painted over an opaque layer, but this will invariably change the color of the opaque layer. The transparent layer is known as a glaze.

Drying and the Final Touches

The drying process of the painting can be manipulated using a heat source such as a hair dryer or a stove. This can be a very helpful technique if the artist is superimposing several layers of paint and does not want the color of the top layers to be affected by the previous ones. Transparent layers of color can be applied to dry, opaque layers in order to modify or saturate the color. The flower on the right, for example, has an orange glaze painted over the petals to modify the color.

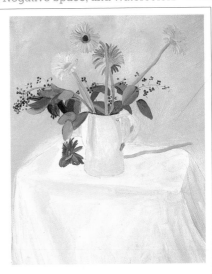

The various opaque colors of the leaves can be superimposed once they've dried completely.

MORE ON THIS TOPIC

· Quick sketches with dense layers of acrylic **p. 80**

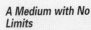

Glazes and whites have been used to paint the tablecloth.

A Medium with No Limits

The acrylic medium allows the artist to create all kinds of artistic work, and for this reason, acrylics are sold in a wide variety of presentations. Each one of these is appropriate for a different use. Traditional tubes of paint are used for painting outdoors or in the studio, while different sizes of tubs with wide mouths exist for the painter who prefers to use great quantities of the medium.

Different presentations of acrylic paint.

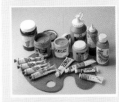

FLOWERS, NEGATIVE SPACE, AND WATERCOLORS

Watercolor is the best transparent medium. Its luminous quality allows the creation of all kinds of colors. The technique used for painting with watercolors tends to be more complex than other painting techniques, primarily those done using opaque mediums, because watercolors do not include white. The artist is forced to work in the negative, in other words, to use colors that will set apart transparent and light areas.

Flower Placement in Watercolor

The placement of the shapes during the sketch is the most tangible guide for using a transparent medium. It is important to pay close attention to this process; otherwise, the artist will not know exactly where to apply the paint. It must be kept in mind that watercolor, as opposed to most other techniques, cannot be corrected once it has been applied. The drawing must be done cleanly and concisely using, for example, a number 2B pencil. The general contour of the flowers must be done first, and the details should be taken care of later.

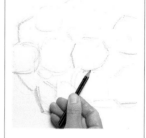

The initial drawing serves to place the general shape of the subject.

Each one of the flowers should be drawn completely.

The Great Reserve

The reserve is the area that has been left blank or unpainted. This allows the artist to take care of the background with a variety of greens, blues, and yellows. The painted area takes up practically the entire surface except for the flowers, which will remain the color of the paper. In order to apply the colors, the artist may use the two basic watercolor techniques alternately, either over a previously wet or a dry background. The first technique allows the color to expand over the entire area of the paper that has been previously wet, while the second allows for a greater control of shapes and forms. The blank area should not include the dark shadows between the flowers; these should be painted.

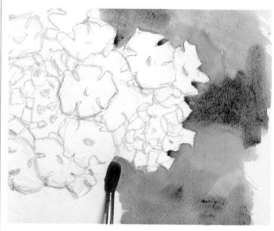

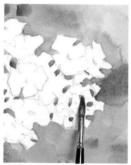

The dark, shadowy areas between the flowers should be painted.

Painting the background without painting the flowers creates a blank area or negative space.

MORE ON THIS TOPIC

- Watercolor—materials p. 30
- Superimposing layers of watercolor p. 60
- Quick sketches p. 72
- Contrast and transparency p. 74

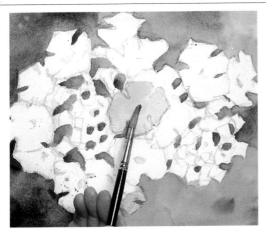

The flowers should be painted individually.

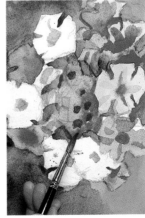

The reddish flowers create new blank areas.

Dark Washes and Light Colors

The artist must wait until the dark background color starts to dry before beginning to paint with lighter colors, because, if any one of these colors touches the wet area of the paper, they could potentially pull the dark color along with them and stain the reserved area. A dry background prevents the light areas from staining. The light colors may penetrate the dark areas without the danger of altering their color. In any case, within the area that includes the flowers, certain tones and colors will be better left unmixed; for this reason it is convenient to first paint one flower and leave the next unpainted, so that no two wet flowers ever touch.

Pure Whites

Because white watercolor paint does not exist, light and color gradation is determined by the white of the paper. These white areas should remain immaculate—from beginning to end—for only then will the artist be able to paint white flowers or create bright areas of light. These areas are nothing but the paper itself.

Water and Watercolors

The amount of water the artist decides to use depends on how transparent the color should be; therefore, it is convenient to always have a container full of water nearby to dip the brush in. Many professional artists use only one container full of water for painting, because as the paintbrush progressively becomes dirty, it tints the water, enriching the color and allowing the composition to become more harmonious on paper.

The brightest areas of light have been left unpainted from the beginning.

TECHNIQUE AND PRACTICE

SUPERIMPOSING LAYERS OF WATERCOLOR

Watercolors allow the artist a great number of color variations that can be created by mixing the paint on the palette or by superimposing layers of color directly on the paper. The paint can then be applied as thin washes of color that will gradually reduce the amount of light reflected from the background. This is a fundamental characteristic of watercolor painting that the artist should keep in mind when painting flowers.

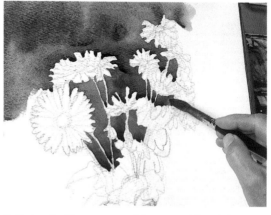

After completing the initial drawing, the background is covered with a wash of color that outlines the subject.

Saving the Flowers in the Background

Watercolor is not the most appropriate medium for painting light colors over dark ones; on the contrary, the medium requires leaving the lightest and brightest colors intact. The artist should take full advantage of this fact, however, for it means that the dark areas of the painting can be resolved in full detail once the areas that should remain the lightest have been established. The development of the light areas can be left for the later stages of the painting, since the colors will not affect the already completed dry, dark areas.

Detailed Background Work

Developing the background of a still life flower painting is as important as the development of the central focus of the painting. Light, depth, and the inclination of the plane on which the model is placed all depend on the background. A dark background will allow the light colors of the flowers to stand out more clearly than if the background were completely light.

The background is wet and stained with a wash of violet-colored ocher and earth tones to create a perfect outline of the shapes of the vase and the flowers. A bluish ocher color gradation should be created in the lower area of the painting with washes of color.

Defining the Shapes of the Subject

Once the background has completely dried, the artist can begin developing the details by superimposing layers to create

A light wash can be used to finish outlining the lower part of the subject.

the shapes of the subject. First, a wash of green will help create the area that corresponds to the leaves and stems of the flowers. This process can take place in two steps: a light wash that will cover everything, and a darker one that, placed over the first, represents volume by creating shadows. A dark red should be used in the

lower area of the painting to represent the places where the flowers lie in shadow. The artist may then move on to develop the stem, in order to allow the recently applied layer of color to dry properly and thus avoid mixing colors. The same procedure should be used to paint all the areas that correspond to the flowers. First, the least transparent colors are applied, and once these have dried, a light wash may be used to cover the surface.

After waiting for the background to dry, the leaves are painted, making sure that color does not run.

Quick Notes

Watercolor is an appropriate medium for taking quick notes or sketching, for a few simple gestures with the paintbrush can create marks that suggest the entire shape of the flower. Also, the amount of paint applied to the paper may be regulated by absorbing it in areas where the color should be more luminous.

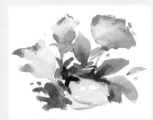

A quick sketch using watercolors.

The Finish and Layering Colors

The final colors added to the painting serve as shadows for the white areas of the paper and consist of grayish, almost transparent washes. Further additions of color are made when the background of the flowers is almost dry; otherwise, the areas where the new colors are applied will lack precision. Some of the dark details have been painted at the end, making sure that the bottom layers of color have dried completely.

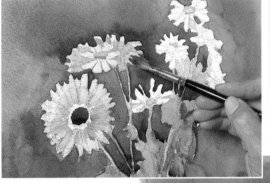

Darker colors are painted over lighter ones to further define the shape.

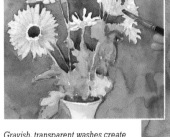

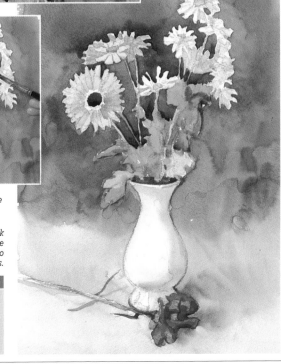

Grayish, transparent washes create shadows in areas of light.

While superimposing dark washes of color, the white of the background has been left intact to represent the lightest areas.

MORE ON THIS TOPIC

- Flowers, negative space, and watercolors **p. 58**
- Flowers with watercolor, on dry and wet ground **p. 62**
- Contrast and transparency **p. 74**

TECHNIQUE AND PRACTICE

FLOWERS WITH WATERCOLOR, ON DRY AND WET GROUND

Two totally different ways of working with watercolors can be developed that will give way to equally different results. When watercolor paint is applied to a wet surface, it expands over the area that is wet creating marks that lack in precision but are very useful for creating background texture and layers of color. On the other hand, watercolor applied to a completely dry surface will follow the brushstroke perfectly.

Drawing the Subject

As with any other painting medium, drawing will be the foundation on which to base the entire watercolor process. The drawing should be as explicit as possible in terms of composition and should suggest the shape of the different elements of the subject. Because watercolor is transparent, it allows one to see the drawing and use it as a guide throughout the entire painting process. The drawing will prove helpful not only during the initial phases but also during the process of reworking the painting toward the end. The shapes and volumes of the subject should be clearly depicted in the drawing, and all necessary changes that serve to accurately define the structure of the subject should be taken care of at this stage.

In this example, the ground has been wet before using the colors.

A Wet Ground

If the artist wishes to paint the background using a wet ground, the areas that will be painted first should be wet, while avoiding areas that will eventually be painted using a different color, such as the flowers or the vase. The background may be wet using a sponge or a brush, the latter being more convenient especially for defining the subject.

The color should be applied immediately to the desired area while it is wet. The paint will run over the wet area, and if other colors are added, they will fuse together. Interesting color gradations can be created using this technique, if the colors belong to the same range. A wet background also allows the artist to control the colors that are being mixed.

The Fusion of Colors

An almost dry background is good for beginning to detail the shapes of the subject. Painted areas that don't overlap with the wet background will remain stable and follow the path of the paintbrush. Any color that touches the wet background, however, will slowly expand toward that area. If the artist waits until the background has dried completely, areas of color can be added that will precisely follow the brushstroke. This is important to remember if the artist wants to add small areas of color to the areas that have already been painted on a wet ground.

Washes of Watercolor on a Wet Ground

Watercolor painting on a wet ground can result in multiple interpretations of shape and technique. Some painters work by fusing all colors in the painting, while others, such as Roman Hennel, work on a wet ground but prevent the different areas of the painting from meeting. The overall effect is very luminous, similar to Gothic stained glass windows.

Roman Hennel, Piwonie. Watercolor on paper.

Every single shape has been detailed in the drawing.

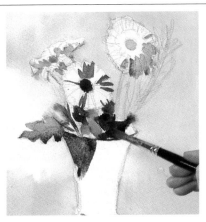

Some colors may fuse if the ground is still slightly wet.

Alternating Dry and Wet Techniques

Once the shapes have been completely defined, the process of developing the painting requires alternating techniques, in other words, painting on dry and wet grounds. The artist should imagine each one of the areas of color in the subject a different painting that can be developed by wetting the background and adding that particular color to it. The artist may also take a detailed approach and work on a dry ground that has been previously fused with color while wet.

Reddish tones have been added to the wet violet area of the vase.

MORE ON THIS TOPIC

- Flowers, negative space, and watercolors **p. 58**
- Superimposing layers of watercolor **p. 60**
- Contrast and transparency **p. 74**

Once the background has begun to dry, each flower can be detailed with chromatic colors.

The various details of the subject can be developed on a dry ground.

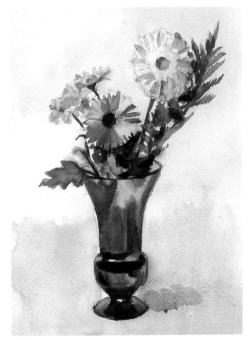

Painting on a Dry Ground

If the ground is dry, the artist can paint with a great deal of precision. The details can thus be developed through small brushstrokes to produce marks. Darker and less transparent colors will be good for doing the detail work, such as the petals, and for adding colors, such as small, dark areas of color over the petals to represent leaves that overlap the flower. This technique is also good for adding depth to the center of the flowers.

TECHNIQUE AND PRACTICE

SUMI-E FLOWERS

Japanese ink painting is one of the most beautiful techniques that can be used to understand flowers, combining the artist's sensibility with the love of reducing shapes. It is hard to define painting with washes of ink as a medium; it is not a drawing technique as the quality of line may imply. The necessary material for this kind of work consists of paper, Japanese or Chinese brushes that can hold relatively large amounts of water, containers, and ink in either solid or liquid form.

Material used for Sumi-e painting: a Suzuri or ink stone, calligraphy ink in solid form, a Chinese brush, and rice paper.

The Simplicity of Nature

Japanese ink painting tends to approach flowers and nature in a very different way than the usual techniques, which tend to depict the subject in a decorative and complex fashion. The Sumi-e technique is characterized by the use of one color to define any shape in nature minimally and with simplicity. Achieving this simplicity of form, however, requires masterful technique. The traditional drawing techniques are left behind and the artist must concentrate on using nothing but washes of color to build the entire painting. The paintbrush is manipulated through gestures; the result does not allow room for error. This exquisite technique can be mastered only through dedicated practice.

Rhythm of Stroke

The ink can be dissolved by wetting the stone and rubbing it in order to create different gray tones. Once the brush is wet with ink, the artist may vary the width of the line depending on the amount of pressure placed on the brush as it runs over the paper. The accuracy of the brushstroke will depend on the steadiness of the artist's hand. Part of the ink can be taken off the paper after each brushstroke by running a clean, dry brush over it. On the other hand, if the artist wishes to darken the area that has been recently painted, a second brushstroke may be applied over it with the same amount of ink. This sums up the basic ink painting technique.

The simple shape of this first brushstroke suggests the form of a leaf. Over this initial shape, another brushstroke has been painted creating a darker area to define the vein of the leaf.

The color can be dissolved with water by rubbing the solid block of ink against the wet stone.

Developing the Flower

It is important to study the structure of the flower using brushstrokes before beginning to paint it. The artist must approach the subject as a group

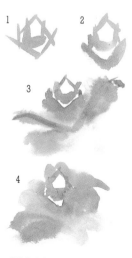

This brief process has been used to paint a rose on a rosebush.

The Legacy of the Orient

During the last decades of the nineteenth century, Impressionist painters began to collect Japanese prints. Eastern art has always influenced Western painters, including contemporary artists such as Carlos Roig, who has appropriated Eastern ideas of composition and balance.

Carlos Roig, Legs. *Mixed media on paper, 11 inches × 15 inches (28.5 × 38.5 cm). Private collection, Barcelona.*

A second brushstroke over a dry surface allows the artist to darken the color and enhance the areas of shadow.

of simple forms, for each one depends on the wash of ink and the time allowed for the ink to dry on the paper. An initial, linear structure created using straight gestures will determine the center of the flower. Before it has dried completely, the surface where the lower part of the flower will be painted is wet in order to create a scale of grays. Using a wet brush, the artist can begin to suggest the whole shape of the flower by developing the shapes of the leaves using dark washes. Based on this shape, the contrast is enhanced by absorbing water off the surface in areas that should be lighter. Finally, the lines that define the branches can be drawn using dark washes of ink to define the leaves.

Variety of Form

One single brush can be used to produce many different effects, as long as it has a good tip that allows the artist a wide range of

With a single brushstroke, the artist can create round petals like the ones on the first flower or the curved petals of the second.

thick and thin marks (thin ones to create branches and other small details). The brushstrokes may vary depending on what part of the flower the artist wishes to paint. The white of the paper should always remain intact to reflect areas of light and provide a reference for the density of the gray tones.

MORE ON THIS TOPIC

- Drawing flowers with ink **p. 42**
- Quick sketches **p. 72**

5

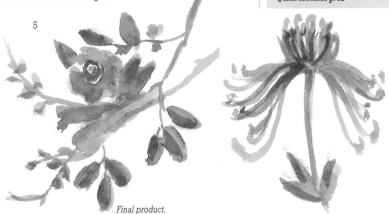

Final product.

USING MASKING FLUID

Masking fluid is essential for creating light areas when working with watercolors. Usually, the artist will simply not paint certain areas that may have been previously determined in the sketch, in order to maintain the white of the paper intact. This approach was used previously to paint the subject as a negative. Other ways of preserving white areas intact exist, however, and they allow the painter to work around them using any kind of ink, watercolor, or gouache medium without the danger of having the color penetrate the designated area. (Gouache is a matte, opaque waterbase paint.) Masking fluid is a liquid medium that is applied with the brush and can be peeled off the paper once it has dried.

Procedure for stretching and preparing the paper on the rigid surface.

Preparing the Surface

A roll of paper tape prepared with gum that will stick with water is necessary so that the paper can be held in place. A rigid surface, such as a board, must be used as well as a sponge and water. The first step is to wet the area of paper that the artist intends to paint using watercolors. The water will cause the paper to expand. Once the paper has been placed on the rigid surface, it must be held in place using the tape. The artist must make sure that the paper and the surface fit together, and before the painting process begins, the paper must be dry. As the water begins to evaporate, the paper will contract, creating tension from being held in place. Note: Wet paper and board must be allowed to dry on a flat and level surface.

The areas that the artist wishes to preserve intact from the water-color paint are covered with masking fluid.

Masking Fluid

The purpose of masking fluid is to protect very precise areas from the paint using a paintbrush. Masking fluid should be treated like paint; it is water-soluble in liquid form, and becomes compact, elastic, and impenetrable once it has dried. The advantage of using this fluid is that it can be peeled off using the fingers or erased once it's dry. Masking fluid should only be applied and removed when the paper is dry.

Washes of Color

Because the most delicate parts of the composition have been reserved, any type of technique can be used without concern, including large amounts of either ink, watercolor, or gouache that have been heavily watered down. The color may be mixed directly on the paper or using large paintbrushes. The reserved area will in

After applying the first washes of color, the masking fluid can be peeled off.

The areas that have remained white can be painted.

Darks placed next to lights will appear lighter.

no way be affected by what takes place on the paper; masking fluid allows the artist the possibility of combining different watercolor techniques, always beginning with a very wet wash that will allow the colors to fuse together. Once the watercolors have dried, the masking fluid may be taken off using the fingers by pinching the elastic film and pulling it off. The shape of the fluid will appear perfectly white on the paper.

Notice the sharp color contrast.

Other Techniques

Other techniques exist for reserving whites, such as wax-resist. The wax can be transparent, and taken directly from the tip of a candle, but colored waxes may also be used. Note: Colored wax contains dye that may stain the area on which it is applied. Wax should be avoided where pure white is desired.

Pure Whites

Because white paint is not used with watercolors, it is very important that the artist know how to use the background white of the paper as a base for creating halftones or simply as pure white areas. In the same way, it is important for the artist to understand how colors complement each other; for example, a color will appear darker if it is placed next to another dark color. This means that grays must always be painted near areas of pure white in order to appear more luminous.

This painting has resulted from the appropriate application of masking fluid and a good use of color.

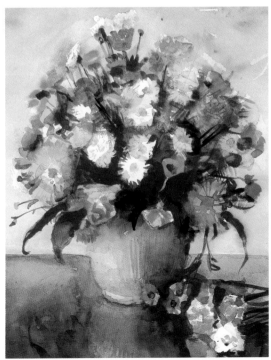

MORE ON THIS TOPIC

- Flowers, negative space, and watercolors **p. 58**
- Superimposing layers of watercolor **p. 60**

USING WAX-RESIST IN STILL LIFE PAINTING

Encaustic painting, a technique that requires using hot wax, has its origins in ancient Greece, where it was once used for both mural and easel painting. This technique is rarely used today, but it has encouraged the development of other techniques that require prepared, cold wax sold in various forms. The application of this medium is much simpler than the one used for working with encaustics, although it is more fragile and unstable. Cold wax, however, allows the artist to create interesting work with flowers.

The Initial Sketch

Wax can be applied to any surface, but if one works with thick layers of paint, it is convenient to use stable surfaces such as wood or stiff board. If the wax is applied in thin coats or dissolved with turpentine, it can be used on good-quality paper. Wax is a stable, opaque medium, that does not allow for correction except through the application of more lines or layers of color. For this reason, it is important to create an initial sketch. The sketch should be vague and general, in order to allow the artist to progressively construct the subject.

Layers of Color

The application of a layer of color using a flat stick should be done with extreme precision in order to avoid clogging the paper's pores. This way, the artist will be able to create areas of color to represent the flowers, and to provide a sketch of the general color distribution of the model. Details must be avoided at this point in the painting. Areas that will be used to paint other forms and colors, such as leaves and green parts of the flowers, should be left untouched during the initial sketch of the composition.

The leaves have been painted in the same way as the flowers; the flowerpot has been painted brown in the darker areas, and the color has been unified using white lines.

MORE ON THIS TOPIC

· Using masking fluid **p. 66**

The sketch combines general lines with white areas in the background to suggest the subject.

Dissolving the Wax

Wax dissolves very easily in turpentine. The artist should take advantage of this characteristic and use the paintbrush to blend, shape, and manipulate areas of the painting. When turpentine is applied to a certain area of the painting, the color dissolves and can be manipulated in liquid form using a paintbrush. The medium will always cover the pores or the texture of the paper when used in this form. The colors that were initially applied with wide brushstrokes will blend together and become compact. Mixing different colors should always be done when the paint is in liquid form.

Using the stick of wax on its side, the artist suggests the general shapes of the flowers.

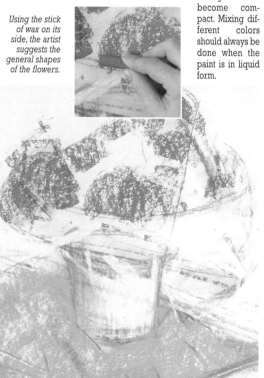

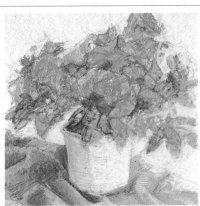

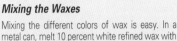

Layers of color that have not been fused together.

With a brush wet with turpentine, the artist may correct, retouch, or blend areas that have already been painted.

Mixing the Waxes

Mixing the different colors of wax is easy. In a metal can, melt 10 percent white refined wax with 25 percent damar varnish. Some carnuba wax may be added (as a hardener) as well as microcrystalline wax (for plasticity). Then color pigment is added, and the mixture is stirred while hot. Once it has cooled enough, the little bars are formed.

Once the colors have already been blended, the artist may alter their tones by adding new colors.

The blending stump allows the artist to blend colors while drawing.

Areas that have been perfectly blended have been combined with areas that show loose and spontaneous gestures.

Colors and Finish

Over the paint previously thinned with turpentine, the artist may retouch or expand areas using the wax stick. A layer of color that has been melted or fixed to the paper through pressure may be altered by applying a different color over it. No color will be able to alter a dense layer of red that has covered the paper's texture if it is applied on the surface of the latter. The additional color will only penetrate the layer of red if it is mixed with it. Additional colors will not affect the layers of color over which they are applied the way they would on paper, but they must be placed almost transparent and blended with a finger or a blending stump.

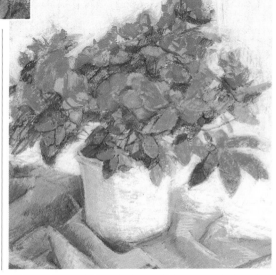

FLOWERS IN A LANDSCAPE

Amateur artists often feel limited to painting flowers inside the house or the studio while making little use of the infinite number of possibilities that painting flowers outdoors can offer. Any medium can be interesting for painting outdoors, but watercolors allow the artist to work quickly and spontaneously, and to capture natural light using few colors because of the variety of colors and possibilities that characterize this medium.

The Subject

The artist is faced with an infinite number of options for treating the subject when working outdoors, ranging from focusing on one single flower to encompassing a wide expanse of land in the painting. Whenever the main motif is a flower, the artist must make a great effort to reduce the shapes in order to differentiate between the main motif and extraneous elements. Understanding the subject on general terms is the best starting point for achieving a concrete form, taking as a reference point the common characteristics of the subject while avoiding representing a particular flower.

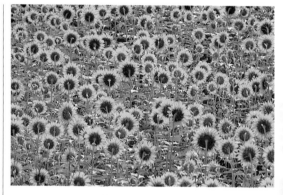

A large field of sunflowers has been chosen as the subject.

The Background

After having decided where the flowers should be located in the painting, the artist may begin to establish what the main planes of the composition are. In order to do this, the artist must clearly be able to differentiate between the plane of the background and the one the subject lies on. Finding a group of tones or colors is useful to understanding the planar structure of the composition. The colors should be present in the landscape and should also allow the artist to create an obvious contrast with the shapes that will make up the first planes.

The painting should encompass characteristics of the subject matter without highlighting any one in particular.

The background is created using a yellowish green.

MORE ON THIS TOPIC

- Flowers with watercolor, on dry and wet ground **p. 62**
- Quick sketches **p. 72**
- Practical resources for watercolor painting **p. 78**

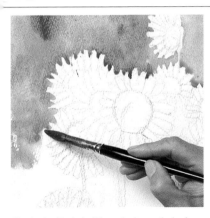

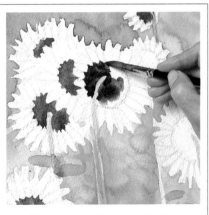

After having blocked off the main shapes, the background is enriched with warm and cool colors.

The green areas of the flowers in the foreground should create contrast with the background.

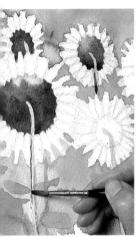

Because a light color has been used to paint the background, it is easy to create contrast with darker tones used in the foreground.

Contrast as a Counterpoint

It is convenient to look for the dark colors of the flowers that are on the first plane in order to create contrast with the background colors. If the green part of the corollas is painted, it is important to create contrast by accentuating the counterpoint of this element with regard to the background color. At no point in the process will dark colors be used in the background; thus, all the other additions of green tones for the leaves and stems will contrast with the lighter colors of the background.

The Lighter Colors

Depending on the technique the artist chooses to use, the addition of the lighter colors will be done at the end of the painting process to avoid losing them with the dark tones. If the artist decides to use watercolors, he or she must be sure to block off or leave the areas that will be painted with the lightest colors untouched. The light colors will be applied to these reserved areas, as it is impossible to paint a light color over a dark one when using this technique. Other pictorial techniques, when used in opaque form, allow the artist to layer light over dark colors. If the artist chooses to work with oil paint, however, he or she must be careful about what colors to superimpose; for example, if yellow or white is painted on a black or vermilion green background, it will crack as soon as the light color dries.

The darkest areas are touched up at the end.

Absorbent Paper

The artist can achieve surprising effects with simple materials if they are used skillfully. A type of absorbent paper allows for the creation of irregular textures with watercolors. Texture can be created on a surface that has been recently painted by simply applying light pressure to the surface using a piece of paper and retrieving it immediately.

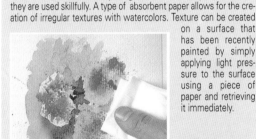

One of the uses of absorbent paper.

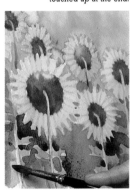

QUICK SKETCHES

Making quick visual sketches is an important part of the painting process. Flowers are a theme that allow the artist free expression and the development of creativity, because of the wide variety of interpretations they offer. The continuous development of quick sketches allows the painter to understand shapes and colors in a minimal or reductive way. This approach can be used throughout the entire process.

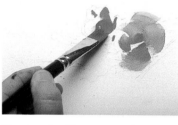

Color is applied directly and spontaneously.

Loose, linear gestures serve to indicate the general shape and the direction of the stems.

Construction Process

The best way to begin making sketches on a subject is by drawing areas that will represent the main shapes of the composition. This process may be based on a previous sketch. The technique should consist of lines or areas of color that represent the general volume of the shapes. The artist's approach to building the shape of the flower through quick sketches can vary depending on whether he or she intends to create a detailed drawing of the composition or not.

From General to Concrete Form

Instead of beginning a drawing by creating dark areas that represent general shapes, a variation on the background color can be established in order to separate it from the group of flowers. The darkest shadows should be applied immediately and

Once the background has been established, the artist must allow for the main flowers to dry.

Any color that is added to the painting will fuse with the wet areas.

directly, and the white areas that serve as background or to represent light should be left intact. Because the artist is working with watercolors and not allowing time for the background to dry, some of the colors will fuse together when they touch other recently painted parts of the surface.

Creating Contrast

Once the general shapes have been established on paper, the artist must allow them to dry a few moments before incorporating dark colors that may not be part of the central focus or perhaps would not mix well with the first colors. All additional shapes will have to be superimposed on the previous colors, making sure that this process does not alter the colors of the new shapes. Similarly, lines may be drawn to represent the stems of the flowers that have been previously suggested through washes of color. It does not matter if the shapes are not concrete, and if they do not express details; the main concern at this point is the composition.

Shapes and Negative Space

Quick sketches can also be used to explain the placement of the subject with regard to the different planes included in the pictorial space by representing the main shapes as negative space. The main planes that make up the subject are established on paper, followed by a simple description of the background details. Tonal variations can be used to express distance between the planes or objects. The main shapes of the

Practical Resources for Making Sketches

The artist may make visual sketches directly from nature, but often it is difficult to find the time for an outdoor excursion. Photographs are a frequently used resource for many painters; they allow the artist to easily reduce the shapes of the subject, given that the choice of composition has already been made by the photographer. Being outdoors will not only be important for the artist to paint, but may also be used as an opportunity to take photographs that can be used in the future.

Photographic material can be valuable documentation for a painter.

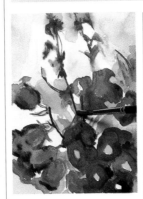

The lines of the stems serve to unify the composition.

subject are outlined by the background; once it is dry, the primary details may be painted, and shadows and color contrasts may be developed.

A Clean Finish

The background should be totally developed using the least number of brushstrokes possible, and focusing more on color than shape, before proceeding to work with lighter colors in the foreground. The light colors will be used to detail the shapes of the flowers by creating contrasts that will define the petals. A light green wash serves to describe light on the lower part of the flowers; once it has dried completely, a dark green is used to finish defining the primary leaf and stem shapes.

MORE ON THIS TOPIC

- The surface and its pictorial treatment **p. 34**
- Framing and composition of flowers **p. 36**
- Composition and structure **p. 38**
- Flowers with watercolor, on dry and wet ground **p. 62**

The background has been painted in two stages: the horizon and the lightest yellow has been applied initially, followed by a darker yellow.

The details will not run with the other colors if the background is dry.

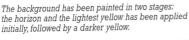

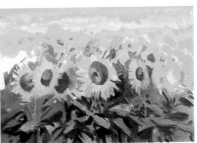

TECHNIQUE AND PRACTICE

CONTRAST AND TRANSPARENCY

Among the various resources that exist for representing flowers, using different techniques alternately is one of the most commonly used. The luminous quality of the different colors of the petals is one of the greatest incentives for creating interesting color contrasts in painting. On the other hand, placing completely transparent layers of color next to opaque areas that represent the objects surrounding the flowers allows the painter to develop interesting combinations of textures.

Using dark colors, the artist can outline the main shapes of the composition.

Establishing Dark Colors

Most of the shapes in a painting will be defined by the contrasts created primarily by the lighter colors, regardless of the technique the artist chooses to use. A dark color placed on a clean piece of paper immediately defines the shapes around it. With this in mind, the artist may outline the main shapes of the subject and thus be able to paint them more comfortably later in the process. The dark color will serve as a reference against which to compare any other color that is incorporated into the painting.

Color Gradations and Contrasts

Color gradations allow the artist to transform one color into another by means of a soft transi-

tion. Technically, each pictorial procedure happens in a different way, and watercolor is the most complex, for its departure point is the white of the paper. An opaque color may be used to create a color gradation by means of a soft wash or glaze. This process requires that a dense color (diluted in very little water) be applied to create a specific shape, such as the central vein on a leaf, and then be brushed over with a lighter color. As a result, part of the darker color will be dragged toward the clean, recently wet area.

Layering Washes

Often, when one layers different tones of the same color, the result will be incoherent, especially if the colors are not somehow fused together. After the color has dried, a transparent wash can help unify the various tones, since they will all share the color that has been added no matter how transparent it may be.

A dark color has been applied.

A light and luminous wash drags part of the first color toward it creating a soft gradation.

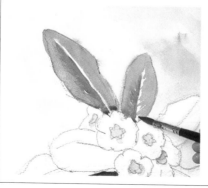

A yellow wash lends coherence to two different tones of green.

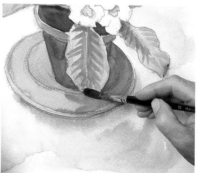

MORE ON THIS TOPIC

- Superimposing layers of water-color **p. 60**
- Flowers with watercolor, on dry and wet ground **p. 62**
- Using masking fluid **p. 66**
- Values with watercolors **p. 76**

Resources for Texture

Another possibility for creating interesting textures with water-colors is to add salt to the wet paint. The salt will absorb part of the water from the paper and will also condense the paint's pigment.

Adding salt to the wet watercolor creates an interesting effect.

Tonal Differences

Once the main elements of the painting have been established, the flowers may be used as reference points for creating contrast. Within the range of colors that make up the flower, it may be possible to find a color that is common to the rest of the composition. It is important, however, that within the variety of tones that make up the painting, one can see the main color of the flower. Tonal differences that create contrast between the shapes will not present a problem for the overall compatibility of the painting.

In this example, the flowerpot is a brick red color. In order to relate it to the rest of the painting, it has been painted using some violet tones; some of the flowers have been connected to the flowerpot using the same technique.

Using the same water for cleaning the brushes to mix and to paint adds coherence to the colors in the painting.

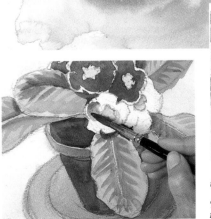

The flowerpot's color has been related to the rest of the composition using the same violet from the flowers.

The shadows on the dirt have been painted blue and red in order to relate them to the color of the flowerpot.

VALUES WITH WATERCOLORS

Studying values in painting means taking an academic approach to studying the effect of light on the different objects of a still life composition. A color's hue varies depending on the amount of light that falls on the object; the color will gradually darken as it moves toward shadow, and will become lighter and brighter the closer it is to the light source. The color of the flowers will also be affected by light, and, in fact, whites will show tonal variations of grays and halftones.

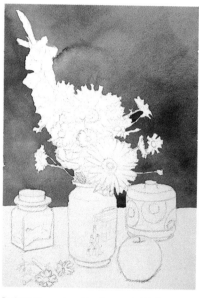

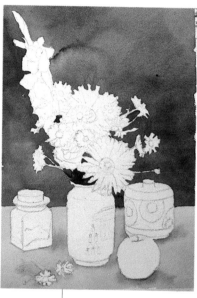

Dark gray serves to outline the model against the background.

Finding the Darkest Tone

An important resource to keep in mind, and one that will help isolate the subject from the background, is to paint the background so that the different elements of the composition are perfectly outlined by the darkest tone the artist plans on using. All areas that will be occupied by the background color, including the shadowy areas between the flowers, should be painted. A second tone, lighter than the one used for the background, allows the artist to establish two basic planes in the composition and to finish outlining the subject's shapes. The areas where tonal variations will be used for creating the sense of volume should be left untouched.

Light and Shine

Areas where light shines on the objects should be established from the very beginning since watercolor paint does not include whites. If the areas that are meant to represent light are covered from the beginning, they will be lost for good.

When painting the first areas, the background must be dry. The colors should be applied using nothing but tonal variations, making sure that no areas are accidentally left unpainted by drying unexpectedly. The first tones are the lightest and should always be applied on a wet surface so that when the darker colors are added, these will blend in, creating gradations that follow the plane of the object. All areas adjacent to the ones being painted should be completely dry.

An almost transparent wash, the same color as the background, establishes the two main planes.

Detail and the Paintbrush

The paintbrush is one of the most important elements for painting with watercolors. If artists prefer to work in great detail, it is recommended they use sable hair brushes because of their perfect tips and the subtlety of line they create.

Before putting away the brush, the tip should be shaped into a point using wet fingers.

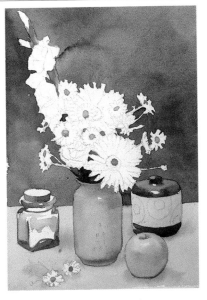

Darker colors are added to the lighter, transparent colors while they are still wet.

Small areas of color are added to the wet flowers in order to give a sense of volume.

MORE ON THIS TOPIC
- Superimposing layers of watercolor **p. 60**
- Flowers with watercolor, on dry and wet ground **p. 62**
- Practical resources for watercolor painting **p. 78**

Gray Tones

Giving shapes a sense of mass with light and shadow can lead to surprising results through accurate tonal gradations. The light source establishes the darkest and lightest areas on the objects, while a light area will be further emphasized if an object in shadow is placed next to it.

Washes of color are layered over the flowers' brightest colors in order to tint them and give them shape by creating light. Colors can be added to a tonal variation while the paper is wet in order to create bright halftones.

Tonal Shades

Once volume has been given to the shapes, the still life is finished by creating different variations of color on a dry surface. The decorative aspects of the composition will be the final details. If the artist wishes to add contrast to a specific part of the painting by means of a color gradation, he or she must wet that specific area of the painting and apply a wash of the desired color.

Colors have been contrasted and decorative details have been created using a fine sable brush.

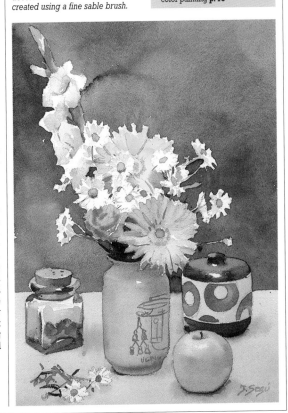

PRACTICAL RESOURCES FOR WATERCOLOR PAINTING

Watercolor is the most complex pictorial medium; however, it is also the one that best allows the artist to create the effect of light. Watercolors also allow the artist to work on an intuitive level, and, in fact, many painters develop their own techniques and resources. Nevertheless, it is always convenient for the artist to know a few practical "tricks" and be able to apply them at any time to the pictorial process.

Technical Summary

If one observes an already completed watercolor painting, one can guess what the primary techniques are that the artist used. Studying other artists' paintings is an important exercise for any artist; even the most experienced artists can learn new resources and techniques from studying other people's work. When artists appropriate a technique that has been developed by another painter, they will inevitably achieve different results once they incorporate it into their work.

Washing out Color

Washes allow the artist to drag paint from one part of the surface to another and to lift it from a particular area. It is wrong to think

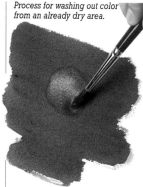

Process for washing out color from an already dry area.

that watercolor painting does not allow room for correction; although the technique requires a great amount of care, patience, and knowledge, washes allow the artist to open up light areas that can later be repainted. A dry color can be cleaned using a sim-

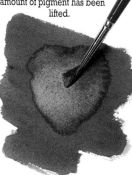

ple process: After wetting the paintbrush in clean water as well as the area the artist wishes to modify, small circular motions will help to loosen the paint again. The brush must always be washed in clean water before going into the painting again; this process must be repeated until the desired amount of pigment has been lifted.

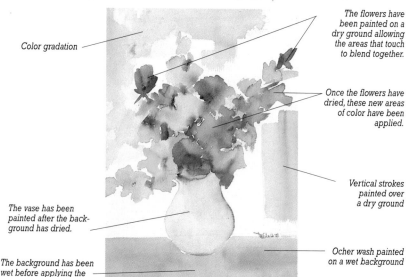

Color gradation

The flowers have been painted on a dry ground allowing the areas that touch to blend together.

Once the flowers have dried, these new areas of color have been applied.

Vertical strokes painted over a dry ground.

The vase has been painted after the background has dried.

Ocher wash painted on a wet background

The background has been wet before applying the wash of color.

Creating a color gradation on a wet ground.

Color Gradations

Color gradations are created by thinning down a color until it blends with the color of the surface it is being painted on or with another color. The process for creating color gradations is practical for creating background and texture. It consists of wetting the area on which the artist wants to work using either a sponge or a clean brush. Color is applied with a brush to the area where it should be thickest and most opaque, and with brushstrokes that follow the direction of the plane, the color is slowly extended so that with each brushstroke the amount becomes less and less. This process is repeated until the color has been completely blended with the background or the previous layer of color.

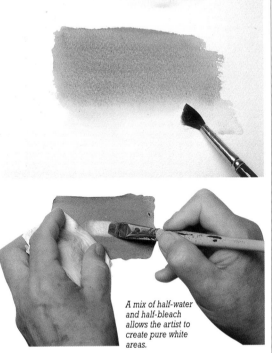

A mix of half-water and half-bleach allows the artist to create pure white areas.

Saving Areas

When using watercolors, flowers are often created by reserving spaces between them that prevent the different areas of color from mixing. In order to avoid the colors of two different areas from blending together, a thin space can be left unpainted that will serve to avoid the two wet areas from coming into contact with each other. Once the first color has dried, the spaces that have been left unpainted may be filled in.

The dry areas between the wet masses prevent these from blending together.

Two examples of color mixed with Payne gray; the first example has ocher tones mixed in.

Creating Darks

Many painters avoid using black when painting with watercolors, as it often has the effect of draining the intensity of the tones that can be created by mixing different colors together. Black paint has the effect of canceling the effect of other dark colors in a painting. It is recommended that the artist use Payne gray instead of black; this color may be mixed with any other without affecting the intensity of the latter.

Creating Pure Whites

White areas may be created on a perfectly dry surface. This allows the artist to correct areas of the painting that have been incorrectly painted or to open light areas that were completed. The success of this technique depends on the paper the artist works with; a high-quality paper will allow the artist to intervene in the painting several times as opposed to a thin, simple kind of paper.

The technique for cleaning certain areas consists of mixing an equal amount of water and bleach together, and using several brushstrokes, creating an area that is pure white and clean. Due to the caustic nature of this technique, it is best to use a lesser quality brush for application.

MORE ON THIS TOPIC

- Drawing flowers with ink **p. 42**
- Superimposing layers of watercolor **p. 60**
- Flowers with watercolor, on dry and wet ground **p. 62**
- Using masking fluid **p. 66**

TECHNIQUE AND PRACTICE

QUICK SKETCHES WITH THICK LAYERS OF ACRYLIC

Acrylic paint allows the artist to easily apply thick layers of paint very quickly, making it a great medium for creating sketches that can later be used for painting with other mediums that require a slower and more detailed process, such as oil paints. Acrylics allow the artist to create quick sketches of flowers and establish a basic foundation for working with oil paint. This process saves the artist a great amount of time and ensures that one of the basic rules of painting is followed: Thick should always be applied over thin.

A quick sketch is painted on a primed surface.

The background colors are applied loosely with a wide brush.

The Newest Medium

Acrylic paint is the newest painting medium. It was invented in 1928 for industrial purposes before the Abstract Expressionist and Pop Art movements appropriated it as an artistic medium in the 1950s and 1960s. Since then it has been used internationally as an artistic medium.

Sketching with Gestures

The acrylic medium allows the painter to work quickly with different layers of color. Painting with gestures is the main approach artists should take to represent flowers, for it allows them to sketch the general shapes of the subject immediately. This will provide artists with a basic idea of where the flowers should be painted, as well as the other elements in the composition. If the surface on which the artist decides to work (either paper, cardboard, wood, or canvas) has been previously primed with acrylic medium, the paint will have more body, for it will not be absorbed by the surface. Quick gestures are the best way for the artist to establish the general composition of the primary shapes.

Applying Dark Colors

The initial sketch will help the artist create a quick series of washes using the same colors from the sketch. It is important to remember that the painting process can be done in stages that do not require the underneath layers to be dry. Planes made of dark washes of color will help create a base on which the light colors

may be layered in the future. A wide brush is useful for creating the initial background sketch using quick and loose gestures.

Superimposing Thick Layers of Paint

Using a heat source to speed the drying of the background,

Yellow has been used to define the general outline of the group of flowers; some of the stems have also been painted.

the artist may begin to apply layers of color that will suggest the flowers. Lines are sketched over the background using a basic color, such as red, to suggest the volume of each of the flowers. Before the paint has dried, thick layers of paint are applied to create the shapes of the petals. The approach should

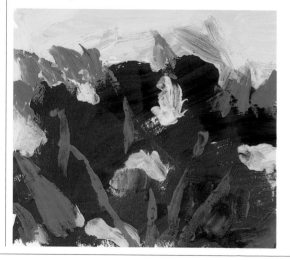

The artist has painted flowers over a dry background using dense layers of paint mixed directly on the surface.

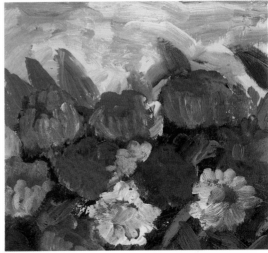

be loose and direct, and the artist should focus on capturing the general shapes of the petals without bothering to define them too much. The colors of the different flowers should be contrasted in a bold way, combining light and dark colors.

MORE ON THIS TOPIC

· Acrylic still life painting **p. 56**

Over a painted background, the artist has begun to suggest the general shape of the flower.

The shape of the flower is defined before the paint has dried.

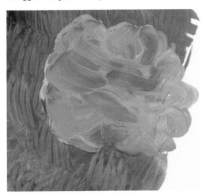

The Quick Sketch

Acrylic paint allows the artist to create quick sketches using thick layers of paint. This is a great advantage over other mediums, as it means the artist can also develop light colors and gradations without having to manipulate the paint in flat layers. Acrylics allow the artist to apply layers of paint that are the same color as the background over the background itself. The strokes of paint must be shaped with the brush and then blended into the background.

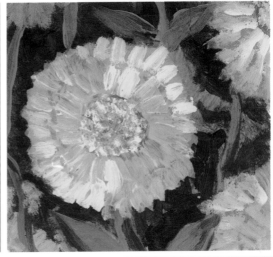

The necessary highlights are painted over the background color.

COLORIST PAINTING WITH OILS

Oil paint allows the artist to create a wide range of colors because it is stable under any kind of light source and the artist is able to create a wide variety of personal effects. After the Impressionist movement and during the last decades of the nineteenth century, artists began to understand color in new ways. The Impressionists did not attempt to create a sense of mass using tonal variations, but instead tried to represent objects through pure, contrasting colors that would, in theory, mix in the eye of the viewer rather than on the palette.

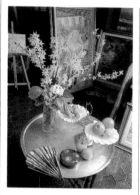

The subject is composed of several elements that vary in color.

From the Subject to the Color Sketch

From a colorist point of view, the artist's work will be strongly influenced and encouraged by a subject that contains a variety of color; thus, it is convenient for the painter to seek objects that vary in color. Keeping this aspect in mind, the artist should create a sketch that is light in color, and begin by suggesting the shapes of the composition using quick strokes. It is recommended that the artist use some of the same colors for the sketch that are in the composition. The initial sketch does not have to be done with thick layers of paint.

Applying Color in Areas

Different areas of color, applied over the initial sketch, will serve as a basis for the general distribution of color in the still life painting. The color is applied in wide areas making sure not to layer the paint too thickly, yet allowing it to suggest the different objects that have already been outlined in the sketch.

Varnishing the Painting

Oil paint dries very slowly from the outside to the inside. If the layer of paint is considerably thick, it may appear to be dry even though the outside layer is the only part that has actually dried. Oil dries by oxidation rather than evaporation, which means that if the painting is varnished too soon, it will seal the paint and prevent the underneath layers from drying. The artist must allow some time to pass before proceeding to varnish the painting. Six to eight months is considered appropriate for work with thin layers of paint; over a year is recommended for anything thick.

An optical effect unifies the different areas of color in this kind of painting.

The first layers are thin washes of paint that suggest the colors that will be added later.

The shape of the fruit bowl is emphasized by adding blue tones to the yellow background.

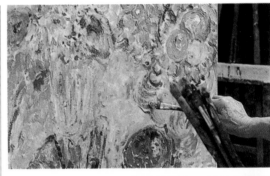

Optical Effects

One of the most important issues the artist must resolve in still life painting is how to treat color. Still life painting will not always be understood based on color gradation and fusion to create mass. Shapes can also be developed using pure colors, both primary (blue, red, and yellow) and secondary. Secondary colors result from the mixture of primaries; for example, blue and yellow create green, the complementary color of red. If complementary colors or a variation of these are applied close to each other, the eye will perceive them as elaborated colors.

Greens are complementary to the warm colors of the background.

Contrast with Complementary Colors

Developing the painting past the initial areas of color means further defining the shapes by creating color contrasts. The contrasts are created by applying colors that are darker than the ones used to suggest the shadowed parts of the objects. Also, complementary colors can be applied directly next to the shapes that need to be emphasized. For example, if violet tones are added to the background on which the flowers have been painted, the yellow tones will become warmer. A similar effect can be achieved by adding green tones to the fruit bowl.

Two techniques have been alternately used: thick, varied layers of paint with bold gestures.

MORE ON THIS TOPIC

- Oil pastels, line and shadow **p. 48**
- Quick painting with oils **p. 84**
- Flowers and highlights in still life painting **p. 94**

TECHNIQUE AND PRACTICE

QUICK PAINTING WITH OILS

Oil is a medium that allows the painter to work quickly, creating immediate sketches of objects and flowers using linear shapes. The color is used minimally, ignoring anything that may be unnecessary to the understanding of the sketch. Oil paintings of flowers should generally avoid excess; instead of overworking the painting, the artist should focus on exploiting the medium in different ways, manipulating the paint with the fingers, allowing other elements to come into play such as the canvas, etc. The painting will be finished and will have reached its limit once the shapes have been explained.

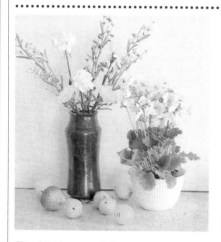

The subject is composed of two flowering plants and some fruit.

The color of the canvas will be incorporated into the overall color of the painting.

Placement of the Main Shapes

The sketch for the painting can be done directly with oil paint by wetting the brush with turpentine and painting when it is almost dry, so that the trace has a rough quality. White paint can be applied directly over the flowers, keeping in mind that the background color will be treated as part of the painting as well. This type of painting allows the artist to use canvas that is not white and to incorporate the particular color that has been chosen for the background into the composition. The color of the canvas will influence the artist's choice of color for painting each object and play an important role in the overall coherence of the work.

The first washes of color that suggest the shapes of the composition are part of the initial sketch. Small and concise strokes will be the next step and will serve to define the green leaves of the plant on the right.

Synthesizing the Flowers

Oil paint allows the artist to paint quickly, directly, and spontaneously so that the painting may sometimes be defined from the beginning. Still life subjects can easily be captured using few lines by creating a perfectly ordered initial composition that will provide a solid structure and an accurate placement of objects on which to develop the painting. In this kind of painting, spontaneous applications of color can be layered over the initial washes; for this reason, the artist must respect the areas that do not require mixing the layers of colors.

The flowers are defined by applying the color directly; the background is painted to outline the subject.

The Process of Elaboration

The area that represents the table is painted with large, gray, green, and violet brushstrokes; it will help outline the shapes of the fruit. The fruit will require only a little color to suggest the shadow.

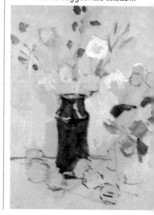

A

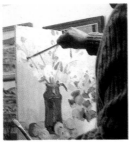

B

C

D

A—By using the palette knife, the artist is able to cover large areas quickly.
B—Quick brushstrokes serve to finish defining the shape of the flowers.
C—Part of the dark color of the vase has been lifted.
D—The fingers are great tools for rapid painting.

Matisse and Color

Henri Matisse (1869–1954), one of the greatest painters of the twentieth century, never belonged to a specific artistic movement but instead drew on all of them to define his own style. He was influenced by fauvism, cubism, and expressionism, and ended up developing a very personal and recognizable style. His work expresses joy and color, and he often used still life compositions as his subject matter.

Henri Matisse (1869–1954),
Bronze and Fruit. *Oil on canvas.*

MORE ON THIS TOPIC

• Oil pastels, line and shadow **p. 48**
• Colorist painting with oils **p. 82**
• Gesture painting of flowers **p. 86**

The palette knife allows the artist to drag the paint evenly across the surface and lift it in order to expose the color of the background through the vase. Using the fingers, it is possible to soften and blend colors and add violet tones over the dark background. Thick, direct brushstrokes will serve to shape the flowers as well as the light areas of the fruit.

painting, since the white will dim all other light areas in the painting, including the shine of the fruit.

Playing with the Background

The vase is painted with a blue-black color, and the light in the background is represented by the untouched canvas. When the background color represents the lightest area in the painting, all other colors will serve to explain the different values in the painting, keeping the background as a reference. The white flowers will create an even greater contrast with the rest of the painting and become the central focus of the

The background has played an important role in this painting.

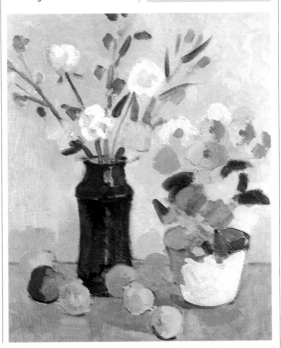

TECHNIQUE AND PRACTICE

GESTURE PAINTING OF FLOWERS

Unique emotions may be transmitted through a gesture in painting, allowing artists to create work that is very personal when they let themselves be guided by this principle. Using a paintbrush, an artist may create immediate gestures that transmit one of the greatest values that an artist can have with regard to painting: sincerity. Gesture painting encourages expressionism and feeling in the artist. Every artist has his or her own way of transmitting emotions, but, regardless of the style, the final product will suggest an experience that should appeal to every painter.

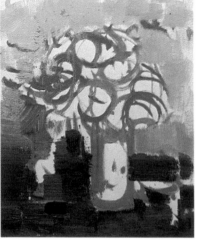

Contrast of Languages

The resources that exist for creating this kind of painting incorporate all kinds of artistic contributions, combining gesture with the practice and technical knowledge of oil painting. The flowers have been painted using only a few direct brushstrokes in a warm, strong color; the rest of the painting is composed predominantly of cool, grayish colors. The combined effect will be to emphasize the primary motif. In the same way that color has been used to emphasize the flowers, the brushstrokes have sought out a flat color and the artist has made use of the palette knife to apply a pink color to suggest warm light on the vase.

The gestures used to explain the shapes of the composition are free and loose.

Different kinds of brushstrokes are combined to create the flowers and the rest of the painting.

Gestures in Drawing

Gestures are essential for creating most works of art. The fluid quality of oil paint thinned down with turpentine gives the creative process a spontaneous feel, and makes sketching easy, for the paintbrush easily slides over the canvas, allowing the artist to paint with strength and gestures.

The placement of the objects should be generic, without forgetting the shapes that make up the subject. The best process to follow is creating a spontaneous and direct sketch that serves to establish the basic composition by depicting the main shapes of the flowers as circles, which in turn fit into a larger, circular context in the painting. The details of the inner shapes should be ignored at this point.

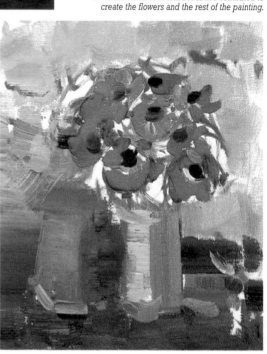

MORE ON THIS TOPC

- Colorist painting with oils **p. 82**
- Quick painting with oils **p. 84**
- Wildflowers with oils **p. 88**

A 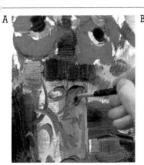 B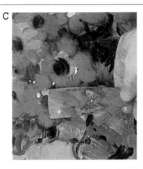

C

The process for finishing the painting may include detail work combined with scraping certain areas using the flat palette knife.

Techniques for Finishing

Once the basic colors of the painting have been established, the artist may proceed to work in a more controlled and spontaneous fashion, always referring to the initial chromatic base. Although the base of the painting has already been established, the details that will give the painting a more concrete aspect are added directly over the fresh color of the initial sketch. The process for completing the painting will consist of two techniques: painting the shapes of the flowers and the vase in a detailed fashion using a fine brush, and lifting the paint to create a rough texture in certain areas of the painting using a wide palette knife as a scraper.

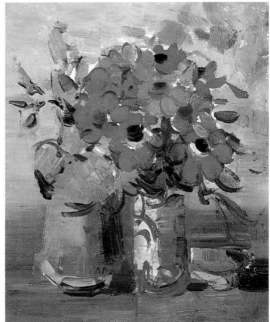

The contrasting techniques used to paint the background and the main figure define the focal point of the work.

Gesture and the Brushstroke

One of the basic elements that defines the artist's sensibility in a floral painting is the quality of the gesture. The artist's particular gesture often transmits as much life as the subject matter itself. The interesting aspect of a still life flower painting is often the approach the artist uses to paint instead of the subject matter itself. For example, Nell Blaine develops a floral motif in this painting, but the strength of the work lies in the line and gesture, the development of the planes, and the impression left by the brushstroke.

Nell Blaine, Bouquet of Flowers. John D. Rockefeller IV Collection.

A Fresh Conclusion

Finishing the painting does not necessarily mean elaborating it to the extreme. If the painting has been done in a quick fashion, focusing on maintaining freshness and spontaneity in the stroke, the artist should not overwork the brush and potentially lose the grace of the work. The brushstrokes may be used to help give color to certain aspects of the background, but should avoid reaching the areas that contain interesting, thick textures that resulted from quick gestures.

WILDFLOWERS WITH OILS

The artist's model may be found directly in nature instead of creating a still life arrangement in the studio. When flowers are studied outdoors or in a garden, elements that are not usually present in the studio will form part of the composition. The play of natural light on the flowers will create luminous colors and emphasize the main color contrasts. The entire composition will become a pictorial theme with a variety of interesting aspects that the artist may later choose to focus on individually in the studio.

The background has been painted with a dark violet tone.

A strong base on which to paint the flowers has been established.

Outdoor Elements

Sketching or painting outdoors will always mean that the flowers are part of a landscape; in other words, the composition will include not only the flowers as a focal point but will also take into account weeds, greenery, or perhaps dry areas of land. A landscape that includes tall weeds provides the artist with a great number of possibilities for representation. The best way to solve this kind of composition using oil paint is to create a dark, violet-colored background as a point of departure. The paint must be thinned down with turpentine, so that different green and yellow tones can be painted over the background to give the dark colors a sense of depth.

Placement of Flowers in a Landscape

A landscape with flowers will always allow the artist to focus on one particular area, creating a point of visual interest with the flowers as protagonists. By focusing on the light falling on the

flowers, the artist may ignore details in the composition that will only detract from the main colors and shapes. By observing the model attentively, one may determine the primary focal points through the areas where the intensity of light—in this case the flowers—is greatest.

Broadening the Color Range

A golden yellow is used to paint the interior of the flowers, allowing the background to show through in certain areas. The weeds that surround the plants will be placed in a minimal way around the flowers, and will

The petals of the daisies are painted over a dark background.

The center of the flowers is painted with a golden yellow color.

incorporate the main color of the background in their development. The first green tone to be incorporated into the painting is light and stands out perfectly against the dark background. Next to this color, burnt tones are added and mixed with black to create shadows and provide an even greater contrast.

Solutions for Painting a Field of Flowers

A rich wash of color that incorporates warm and cool colors is used to create the background. It is very important that the brushstrokes follow one direction and that the groups of color explain the different planes of the landscape. Once the flowers are painted, the background will appear deeper in areas where it is darkest. Finally, areas of color to suggest the flowers will be placed over a perfectly finished background.

Complementary Material

Using a camera is often a necessity for a landscape painter. Landscape painting is not always done outdoors, and the work performed in the studio is very important for developing certain aspects of the painting in a more meticulous and relaxed way. For this reason, good photographic equipment is indispensable to any landscape painter, allowing the artist to create images that will serve as reference material.

Greater contrast is created by using darker tones for the background.

MORE ON THIS TOPIC

- Using oil paint **p. 28**
- Colorist painting with oils **p. 82**
- Quick painting with oils **p. 84**
- Gesture painting of flowers **p. 86**

A background that is rich in color has been created.

Flowers are painted on the background using small, light spots of color.

CONTRAST AND VALUES

There are many ways to create contrast between the subject and the background or between the focal point and the other elements of the subject. A group of flowers may be understood from a colorist point of view, or by depicting tonalities and color gradations that become darker in areas of shadow and vice versa. Painting using color gradations is a good way to create a sense of volume in the flowers; the painter should use this technique to describe the planes and mass of the flowers.

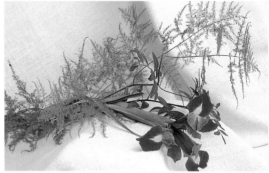

The light that reflects on the subject is soft because it is indirect.

Colors and Gradation

Oil paint makes it easy for the painter to superimpose and blend colors. Understanding the values that describe the flower means understanding the subject based on the light that falls on it. The colors that lie in shadow will inevitably require using darker tones of paint than the colors of the illuminated areas.

The way the artist chooses to depict the flowers in a composition depends on the way the light falls on these and the intensity of the illumination. The closer the subject is to the light source, the softer the shadows will be. If the source of light is indirect or bounces off another surface, the color will softly fade from light to dark.

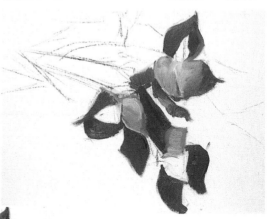

A darker color has been used initially, and white has gradually been added to it to create lighter tones.

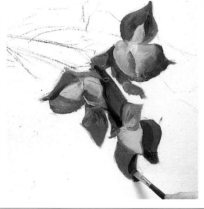

Increasing the Contrast

Once the first color gradations have been done, complementary colors may be added to the painting (yellow in this case). In the same way that light affects the violet-colored areas of the painting, yellow affects the color of the flowers as it reflects on their curved surface. This reflection is perceived as a shadow, and is the result of a medium yellow color mixed with a small amount of violet. Painting with yellow makes it necessary for the artist to increase the contrast on the petals by adding a bluer violet to paint the shadows.

The internal part of the flower is done with a mix of yellow and a small amount of violet.

Colors and Volume

Painting with flat colors is very different from using tonal variations; this does not mean, however, that flat color may not be used to express volume, but rather that the approach must consist of contrasting colors rather than creating a color gradation. The colors used to create the effect of volume will depend on the position of the object with regard to the light source. For example, the branches of the flowers can be painted using only one color, but once dark colors are added to describe the areas in shadow, and are blended in with the initial color, an obvious study of light and shadow has taken place. If light colors are added and blended with the color of the foundation, a complete study of values has taken place.

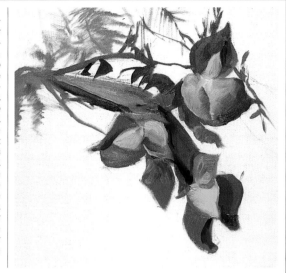

The branches are painted using primarily one color.

Darker and lighter tones are added and mixed with the color of the foundation.

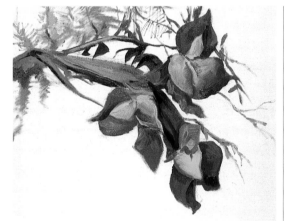

<div style="border:1px solid #000;">

MORE ON THIS TOPIC

- Using oil paint **p. 28**
- Gesture painting of flowers **p. 86**
- Flowers and highlights in still life painting **p. 94**

</div>

A practical equation for creating the shadow colors.

The Infallible Formula

There is a way to determine the exact color of the shadows based on the color of the surface that is about to be painted. The first step requires darkening the hue of the color in shadow; its complementary color is added and once it has been perfectly incorporated, a touch of blue is added. The volume of the rose petals is done by painting each shape using a specific color value. A dark sienna (the darkest tone available), brilliant green (its complementary color), and a small amount of blue are used to determine the shadows.

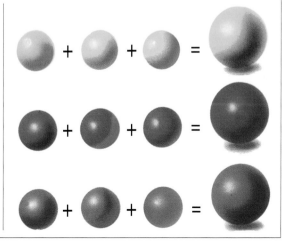

TECHNIQUE AND PRACTICE

COLOR CONTRASTS USING OILS

Contrasting colors is a frequently used pictorial technique that allows the artist to depict shapes based on their color and the way they react to their adjacent color. When complementary colors are placed next to each other, they react and create a vibrating effect. Similarly, if a painting is fairly monotonous in the tone or density of color, a group of darker tones may be added to make the initial colors appear lighter and brighter.

Contrast in the Beginning

By creating color contrasts, the artist is able to make a dull color come to life. This optical effect happens by placing a darker color next to the one that needs to be lightened; if the dark color has tonal variations, the light color will appear even more luminous. By observing the subject closely, one can see how the gray background makes the flowers appear more luminous. The shapes must be represented in the same way, using a dark green wash to suggest the stems and leaves, and using a gray background to bring out the white flowers.

Pure Colors and Shadows

The artist should always use pure colors when beginning to determine the different colors of the flowers; these can be modified directly on the canvas by adding more paint of the same tone. Initially, these light, pure colors serve as a reference for any other color that may be added. They will also suggest the actual color of the flower without taking shadows into account. Shadows must be added in the beginning by darkening the initial background color with warm and cool tones. Adding yellow to cool colors will make these greener, while adding it to warm tones will tend to give them an orange hue.

MORE ON THIS TOPIC

- Using oil paint **p. 28**
- Colorist painting with oils **p. 82**
- Quick painting with oils **p. 84**
- Gesture painting of flowers **p. 86**
- Flowers and highlights in still life painting **p. 94**

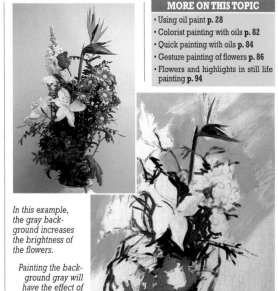

In this example, the gray background increases the brightness of the flowers.

Painting the background gray will have the effect of emphasizing the flowers, without the need for any further modification.

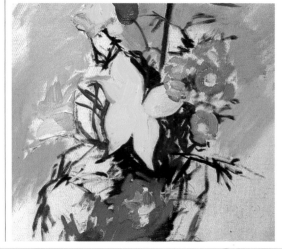

The colors of the flowers have been applied in their pure form. The areas in shadow will depend on small additions of warm and cool colors.

Increasing the contrast will make the lighter colors shine more.

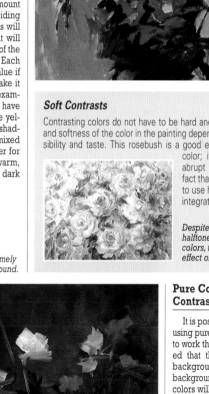

In order to maintain the warmth of the colors, violet tones are added.

Increasing Light, Increasing Shadow

The background color will remain untouched in places where the artist wishes to describe light areas on the flowers. The softer shadows will be painted by increasing the amount of color in certain areas, avoiding the lightest parts. The petals will have contrasting colors that will appear lighter if the colors of the shadows are darkened. Each color takes on a different value if its density is changed to make it appear as a shadow. For example, the green tones that have been used to cool down the yellows will turn into earthy shadows once they have been mixed with the red flowers. In order for the shadows to appear warm, they should be mixed with dark red tones.

The light colors appear extremely bright because of the background.

Soft Contrasts

Contrasting colors do not have to be hard and abrupt. The subtlety and softness of the color in the painting depends on the artist's sensibility and taste. This rosebush is a good example of subtlety in color; it does not have any abrupt contrasts due to the fact that the artist has chosen to use halftones and white to integrate all the other colors.

Despite the fact that the halftones are complementary colors, they have a unifying effect on the painting.

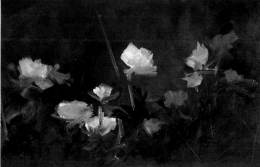

Pure Color and Its Contrasts

It is possible to create contrasts using pure colors. If artists choose to work this way, it is recommended that they use a single-color background. The darker this background, the brighter the light colors will appear. A flower painting does not need to be very complex in order to be beautiful. Often, the best results derive from a few contrasting colors that together suggest the entire shape.

FLOWERS AND HIGHLIGHTS IN STILL LIFE PAINTING

Oil paint is the best medium to use in still life painting of flowers because of the numerous possibilities it offers for creating finishes that produce a variety of textures and shines. Using photographs as a reference, artists may study the way the light reflects on the glass much more easily than if they were looking at the actual subject. Oil painting allows artists to combine several different techniques in one painting, including layering and blending colors or extending them into the blank areas previously reserved.

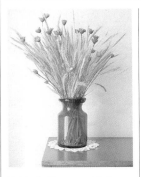

Light reflecting on crystal often poses the greatest challenge to an amateur painter.

A monochrome painting may split these two colors.

The initial sketch leaves certain areas untouched in order to describe the lightest points in the photograph.

Monochrome Painting

Creating light in a still life painting tends to be the greatest challenge an amateur painter is faced with; however, this issue may easily be resolved from the beginning with a sketch. The best way for a painter to understand light is by working on monochrome paintings, and using photographs as models. Photographs will allow the artist to closely study each element of the composition without being overwhelmed by the complexity of the real subject. Creating a series of monochrome paintings will make it easier for the artist to understand how the light reflects off each element, as well as the intensity of the contrast depending on how light reflects on crystal, in this case.

Treating Contrast as a Drawing

A play of colors may be created using nothing more than a mixture of white and black paint, and treating the work as if it were a charcoal drawing with sharp, contrasting values. The white of the background will become the focal point once the various gray tones have been painted to suggest the shapes of the subject and cover the background almost entirely.

Creating Different Tones

Because the background is still fresh, the color will blend easily. The various gray tones are created by adding white paint to the fresh black paint; the paint may be mixed directly on the surface with a brush. If the color is too light, the artist may add a bit of black paint, keeping in mind that it is always easier to darken a color than lighten it. The bottom part of the background has been darkened using an ascending gray scale in order to emphasize the shape of

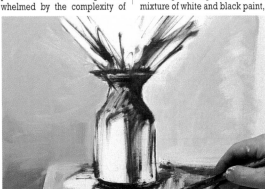

The background gray has been darkened at the bottom of the painting.

Avoiding Gimmicks

Painting light in a realistic fashion is a very interesting skill to have, for it allows the painter to achieve amazing results; however, a good painter must try to avoid using gimmicks particularly when painting flowers. Light should be used moderately and effectively in order to avoid distracting the viewer from the actual subject matter and creating nothing but a display of light.

the table. The light reflecting on the crystal has been created using gray tones where the light is dimmest, allowing the white areas to suggest shine.

Light and Colors

If the still life painting is going to be based solely on color, the artist should pay careful attention to adjusting the different tonalities that have

MORE ON THIS TOPIC

- Using oil paint **p. 28**
- Colorist painting with oils **p. 82**
- Quick painting with oils **p. 84**
- Gesture painting of flowers **p. 86**
- Contrast and values **p. 90**

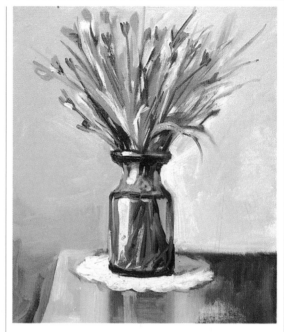

already been studied in the monochrome painting. The monochrome painting has the purpose of helping the artist understand light and how to paint it. Because oil painting allows the artist to apply white paint to create light areas at any time in the process, certain areas do not have to be left

The flowers have been painted using quick strokes, and the areas of light have been emphasized by deepening the dark colors.

blank for this purpose. The color of the crystal will affect the color of the objects that are seen through it.

The brightest areas are where the light reflects off the color of the crystal.

The color, shape, and thickness of crystal will affect the color of anything located behind it.

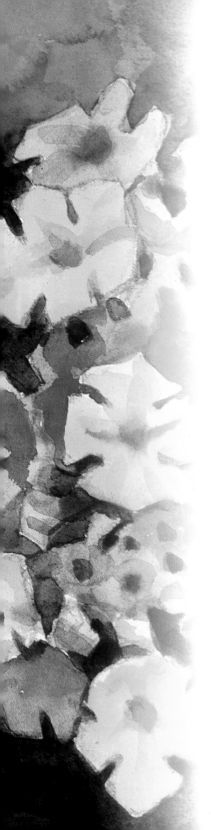

Original title of the book in Spanish: *Flores*
© Copyright Parramón Ediciones, S.A. 1996—World Rights.
Published by Parramón Ediciones, S.A., Barcelona, Spain.
Author: Parramón's Editorial Team
Illustrations: Parramón's Editorial Team
Copyright of the English edition © 1997 by Barron's
Educational Series, Inc.

All inquiries should be addressed to:
Barron's Educational Series, Inc.
250 Wireless Boulevard
Hauppauge, New York 11788

International Standard Book No. 0-7641-5014-6

Library of Congress Catalog Card No. 97-72888

Printed in Spain
987654321

This collection consists of four series:
RED SERIES: Pictorial themes
BLUE SERIES: Techniques
GREEN SERIES: Various themes
YELLOW SERIES: The history of painting

Note: The titles written at the top of each odd-numbered
page correspond to:

The previous chapter
The current chapter
The following chapter